Visit to Amish Country

By Raymond Bial

PHOENIX PUBLISHING

ISBN I-886154-02-3

Manufactured in the United States of America.
Printed on acid-free paper.

Phoenix Publishing
300 West Main Street
Urbana, Illinois 61801

Contents

Preface

IN A SENSE, *Visit to Amish Country* began over three decades ago when I was a boy living on a farm near Elkhart, Indiana. There were a number of Amish settlements in the region and when driving through the countryside with my family I often glimpsed a horse and buggy clip-clopping along the asphalt. One summer afternoon my brother William and I actually got to visit an Amish family with our father. While the fathers talked business, two of the children in the family, a boy and a girl, shyly approached William and me.

About eleven or twelve years of age, we were all young, eager, and curious, so any apprehension about our differences was eased by smiles of acceptance. In fact, we were immediately caught up in the excitement of becoming acquainted with someone new. Bright-eyed and full of energy, the Amish children were thrilled to show us as much of their farm as possible during the brief visit, and William and I were excited to learn more about how they lived. Even as a boy, I loved to absorb the atmosphere of a new place, as well as the sights and sounds around me. I took in the large yard where children could really run loose and the woods and fields unfolding in every direction. Delicately hinting of the joy of that yard, a rope swing with a board seat dangled from one of the oak trees grouped by the white clapboard farmhouse.

The children led us through their vast barn with its intricate network of beams, and I imagined them playing in the loft of fragrant hay. They showed us where they shelled corn in the barn and I imagined working those long hours—they assured us that it was great fun. Later, I learned that all social gatherings whether for work or play were called "frolics." We followed them next into the barnyard. They showed us a large concrete water trough where they kept a few small fish. I was fascinated by the bluegill, minnows, and shiners the children had caught in the creek branching through their pasture. I, too, liked to net fish in the creek near our house, but lacked a deep, spacious tank in which to keep my prizes. In the shade cast by the barn, we watched the fish zip back and forth in the crisp, mellow water.

As a special treat, to culminate the visit, the children asked their father if they might take William and me on a buggy ride. With a ripple of a smile, their father approved of the plan. In fact, both fathers seemed to be very pleased that we children were having such a delightful time together. We all watched as the boy hiked out into the pasture to fetch a horse. However, the horse was perfectly content to be grazing and kept veering away. Trying a different tack, the boy kicked a tuft of grass and nonchalantly eased up to the horse, who wasn't fooled for an instant. The boy next tried to approach sideways, but the horse again trotted off. The boy walked away, and I was about to give up on our ride, but he had only gone as far as the orchard and returned with a gleaming red apple.

The horse immediately perked up at the sight of the apple, and the boy managed to draw near enough to slip a rope halter over its nose and ears before letting it have the treat. He led the horse into the yard and harnessed it to the buggy. Both fathers approved of the boy's competence in handling the horse, and William and I were especially thrilled to go on our first buggy ride.

Allowing themselves a glimmer of pride, the children told us that the horse was a retired harness racer—and fast! Once out of sight of the house, we sped up. On either side of the road the trees blurred past, and the wind swirled through the open sides of the buggy. From the vantage point of our car, buggies had always appeared slow to me, but I could see now that it was only a matter of perspective. When enclosed in the glass and metal capsule of a car, it was always hard to directly experience anything. Now, however, I felt every bump in the road, every surge of the horse, every sway of the buggy, and the wonderful tingling sensation that we were really flying down that country road.

All too soon, the sun began to melt into the ragged line of trees at the edge of the sky, and we were back in our car, saying goodbye in the dusk, promising to see each other soon. However, we never did meet again, and I don't remember the names of the children, or exactly where they lived in Elkhart County, but the memories of that day have stayed with me to this very moment.

Today, whenever I visit an Amish community, I am reminded of my boyhood ride in a buggy—of the experience of being so much out in the open, so rooted to the land and everything around me. ✻

A Way of Life

THE AMISH ARE often considered different, out of step, even peculiar. Yet to me, it is the monotony of superhighways, the congestion of highrises, and the proliferation of shopping malls that are alien to nature and the human spirit.

When looking at our landscape of glass, concrete, and steel, I see that the Amish as traditional farmers have kept their appreciation for soil—whether strolling down the aisles of corn or spading the garden. As craftspeople, they prefer wood, both in the grandeur of their barns and in the simple elegance of their handmade cabinets. Amish women are known far and wide for their ability with cloth, both in the delicate stitching of their quilts and in the utility of homemade clothes. These natural materials embody the spirit of the Amish, who have always preferred to be traditional farmers or craftspeople. The Amish also make their homes in the country, where their children can wade in creeks pursuing elusive fish or roam the woods and fields.

Over the years, I have visited Amish communities in Pennsylvania, Ohio, Indiana, and Illinois, taking occasional photographs. About five years ago, I decided to begin work on a series of photographs that would evoke the "interiors" of Amish life. Of course, I am not Amish and, although I've admired them, I clearly approach these people as an outsider. Yet, having spent the most meaningful years of my childhood on a small farm, I have always felt an affinity with the Amish. As I was taking photographs on weekend trips, I also took the

time to read widely about the Amish and made every effort to understand their way of life.

The two most obvious lessons were that the Amish do not appreciate intrusions and, more specifically, they do not wish to be photographed. The Amish often refer to the biblical admonition against the making of "graven images." More importantly, they believe it is prideful to draw attention to oneself. "You may not take any pictures of me," one Amish woman told me, "but you may photograph anything I own, because worldly goods do not matter to me." Shyly grinning as he shoed a workhorse, another young man remarked, "Sure, you can take all the photographs you want, just so I don't get in any of them!"

No portraits of the Amish themselves are included here. Out of respect for these unassuming people, on every visit to Amish country I tried to be considerate and assured them that I would not photograph them. In photographs of buggies moving along the rode and of a woman pedaling a bicycle, I was careful to keep a respectful distance and *not* to include faces. Through photographs of buggies, quilts, tools, clothing, and other outward symbols of Amish culture, I found it possible to evoke the inner calm distinguishing their lives. A grouping of chairs on a porch can often be more revealing about the inhabitants than explicit portraits. According to an old German saying, one can best know people through their work. In this way, we may accurately and sensitively understand the Amish through their homes and the objects

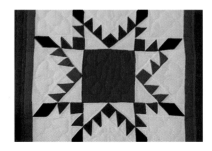 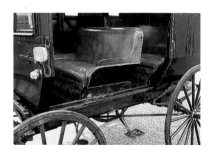 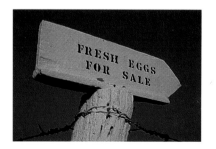

they create. Although the Amish do not place any value on these "worldly goods," these material possessions very much embody the spirit of their lives. They are a remarkable people who have always valued work, family, and community.

I am not alone in being drawn to the Amish. Every summer, waves of tourists descend upon their communities scattered around the United States and Canada. In many of these places, over the course of the season the tourists outnumber the Amish themselves.

Why is there such a deep fascination with the Amish and their way of life? The fullest answer may lie not so much among the Amish but within ourselves. As author Janice Holt Giles wrote several years ago, "We live in a time and circumstance that breeds feelings of insecurity, not only because of the world situation with its ever-present threat of tensions and war, but because we have created a very complex civilization, fast-moving, noisy, crowded, and nervous, in which we are not entirely at home. It has come too fast and our personalities cannot adjust to it fully. Most of us remember, or at least our parents can remember, a slower day, a quieter day, and in our memories perhaps, a sweeter day."

Perhaps visitors to Amish country are looking for their own quieter days. Perhaps they seek not so much a lapse into nostalgia, but a respite from the social, cultural, and economic problems of today and their corresponding tensions. By contrast, the world of the Amish is generally placid. They even have

a German word for this feeling, *Gelassenheit*, which means "serenity" or "composure." This sense of tranquility, along with a pervasive humility, is at the heart of Amish life.

At first glance, the country where the Amish live appears to be like any other rural landscape. The shimmering ribbon of asphalt undulates with the ebb and flow of the land. Queen Anne's lace, black-eyed Susans, and blue chicory fringe the road's shoulder, and the fields unfold in a patchwork of green all around. But then, in the distance, a horse and buggy emerge from the lingering mist of first light, as if surfacing from a dream, as if materializing from an entirely different time and place.

Among the Amish, the horse and buggy not only serve as a practical means of transportation but also symbolize a belief that they must be "plain and simple" people who separate themselves from the world. They frequently say that they are "in the world, but not of it."

The Amish have indeed rejected much of modern technology, including radios and televisions, as well as the automobile, but they are hardly stuck in time. They are not opposed to progress, including modern conveniences, as long as their deeply held beliefs regarding family, community, work, and religion are not threatened. Far from being the "plain people," as they are often called, they have fashioned their own complex and dynamic society. ✖

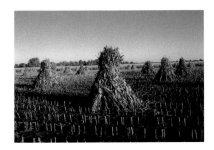

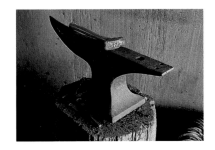

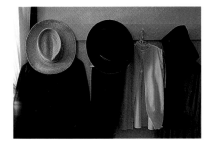

Beliefs

THE AMISH ORIGINATED as a religious sect in Europe, generally in the region known as Alsace-Lorraine, where they suffered persecution for many generations. Like Martin Luther and other leaders in the Reformation, the Amish broke away from the Catholic Church, believing that religion was a matter of individual conscience and that no church could offer divine grace through its organizational structure. An offshoot of the Mennonite Church, the Amish took their name from their founder, Jacob Amman of Switzerland. Seeking religious freedom, the first Amish settled in Pennsylvania in 1737. Immigration to the United States continued through the 1800s.

Generally, the Amish call for the separation of church and state, a literal interpretation of the Bible, a voluntary church of adult members, and nonconformity of Christians with the rest of the world

Ardent pacifists, the Amish emulate the peaceful example of Jesus Christ regardless of the cost. Through the 1600s in Europe, many were burned at the stake or put in sacks and thrown into rivers because their practices differed from those of the dominant church. Virtually every Amish home reserves a special place alongside the Bible for the *Martyr's Mirror*, a book chronicling Amish history.

Amish beliefs are similar to those held by other Protestant denominations in the United States. The Amish profess, however, that they must separate themselves from the world if they are to attain the goal of eternal life. Their pacifism permeates every aspect of their lives and results in a tranquil atmosphere around their homes. Most of their beliefs and daily practices are codified in the *Ordnung*, an unwritten set of rules that has evolved over the years. Church leaders from districts and regions also meet periodically to discuss and revise practices. Although men occupy all the official positions of leadership in the community, women play a central role in their society and are responsible for the continuity of the Amish way of life.

Although the Amish do not actively seek new members, their communities have grown because they have large families, averaging seven or eight children. Teenagers are allowed some independence until their late teens or early twenties, at which time they must decide whether or not to join the church. Young people often join the church when they are ready to marry and settle down with a family. Once an Amish youth is baptized into Amish adulthood, he or she is expected to adhere to the rules of the church. There are now over 125,000 Amish living in 25 states, primarily in Pennsylvania, Ohio, Indiana, Illinois, and Iowa. There are also Amish settlements in Canada, but no Amish remain in Europe.

It was not until the early 1900s that the Amish appeared different from their non-Amish neighbors, whom they call the "English." As the rest of the world seized upon the use of modern technology, notably the automobile, the telephone, and the radio, the Amish continued to drive their horses and buggies. ✖

Blacksmith shops still dot the landscape in Amish country, along with buggy shops and other businesses that cater mostly to the plain people. Today, Amish blacksmiths primarily repair farm equipment.

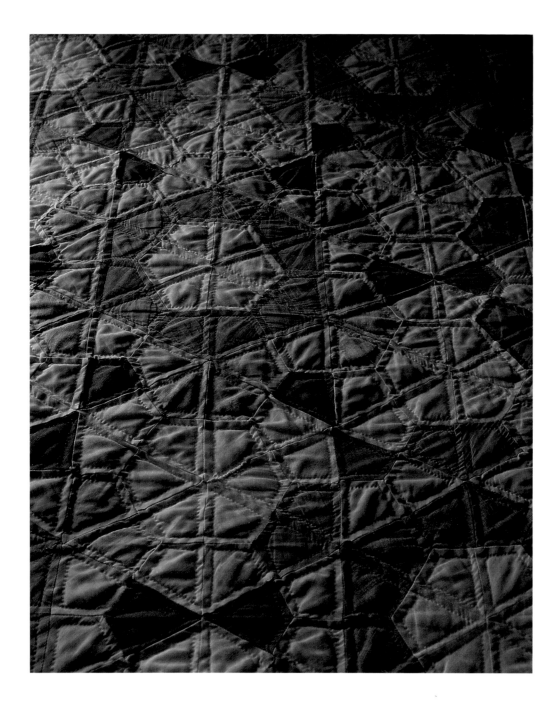

Quilts may adorn beds in Amish homes or be offered for sale. The quilts are highly prized by tourists and collectors who visit Amish country. Since it includes fabric with a representational pattern, the quilt above may not be used by the Amish; it will be sold to tourists.

Nothing embodies the spirit of quality and cooperation more than the striking quilts meticulously stitched by groups of Amish girls and women. None of the quilts kept by the Amish may have representational images, only geometric patterns. However, the designs are intricate and lovely.

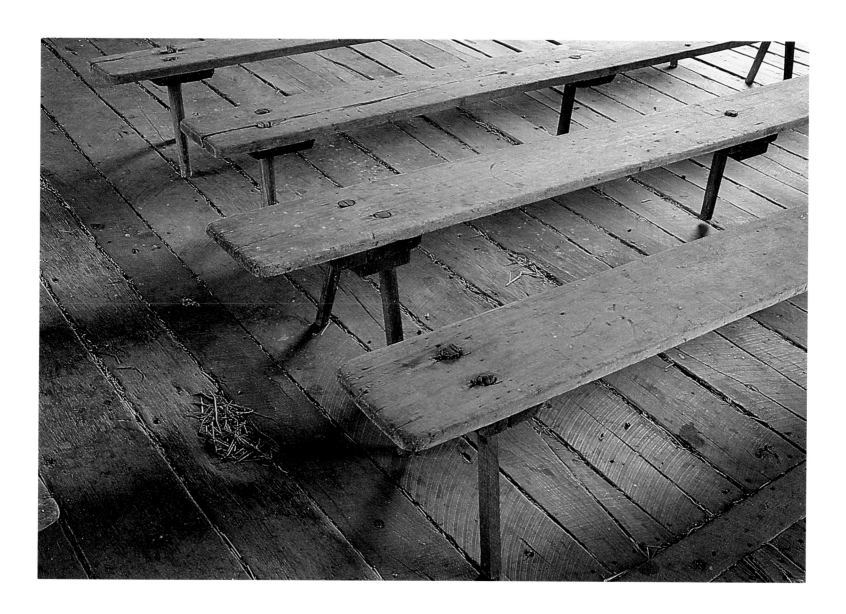

The Amish do not have church buildings. Services are held every other Sunday, on a rotating basis,
in the homes or barns of the families that make up the religious district, or Gemeinde.
Benches have been set up in this century-old barn in preparation for worship.

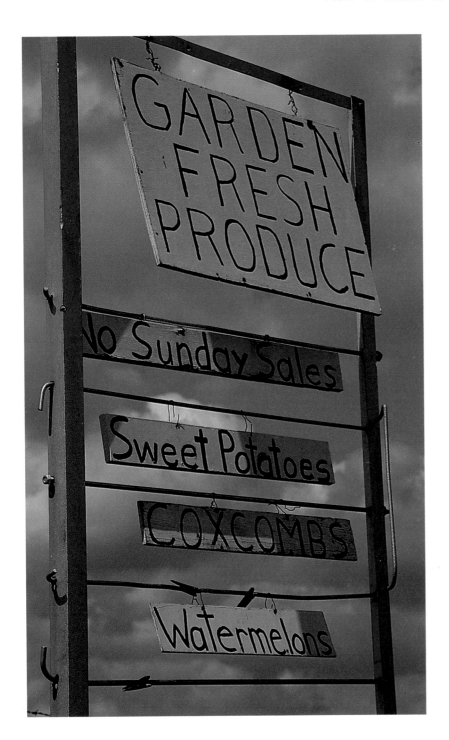

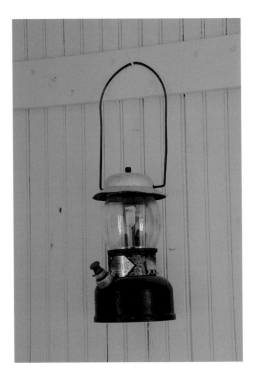

A kerosene lamp hangs on the back porch of an Amish home, where it comes in handy for late-night trips out to the barn. Lamps and other items unique to the plain people are offered for sale in dry goods shops in Amish communities.

This sign flutters in the crystal light of autumn. Always practical, the Amish prefer signs that may be readily changed to indicate what produce is currently in season. Virtually all signs include the notice "No Sunday Sales" or "Closed Sundays."

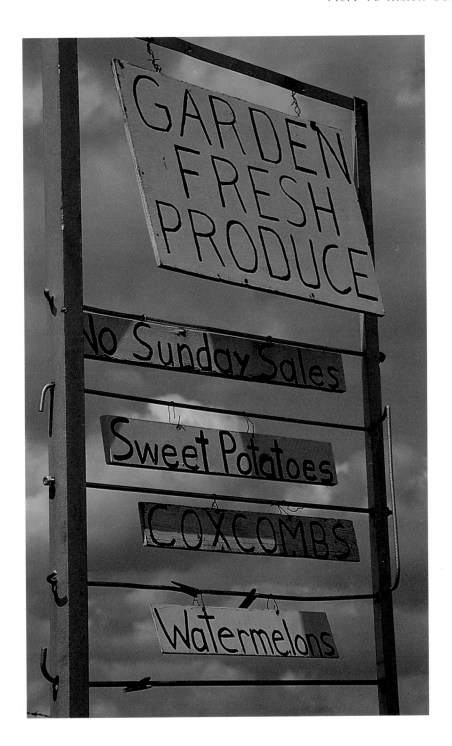

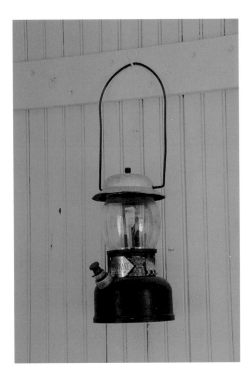

A kerosene lamp hangs on the back porch of an Amish home, where it comes in handy for late-night trips out to the barn. Lamps and other items unique to the plain people are offered for sale in dry goods shops in Amish communities.

This sign flutters in the crystal light of autumn. Always practical, the Amish prefer signs that may be readily changed to indicate what produce is currently in season. Virtually all signs include the notice "No Sunday Sales" or "Closed Sundays."

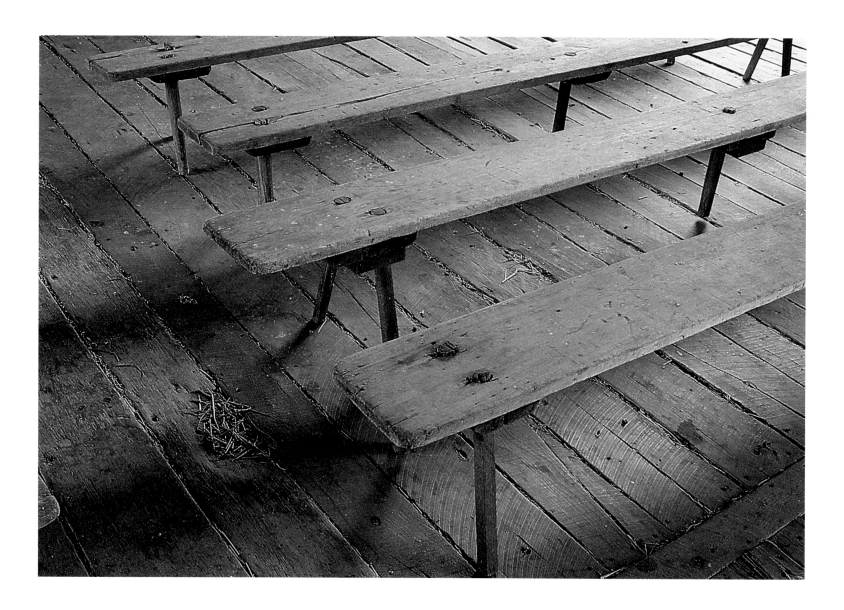

The Amish do not have church buildings. Services are held every other Sunday, on a rotating basis,
in the homes or barns of the families that make up the religious district, or Gemeinde.
Benches have been set up in this century-old barn in preparation for worship.

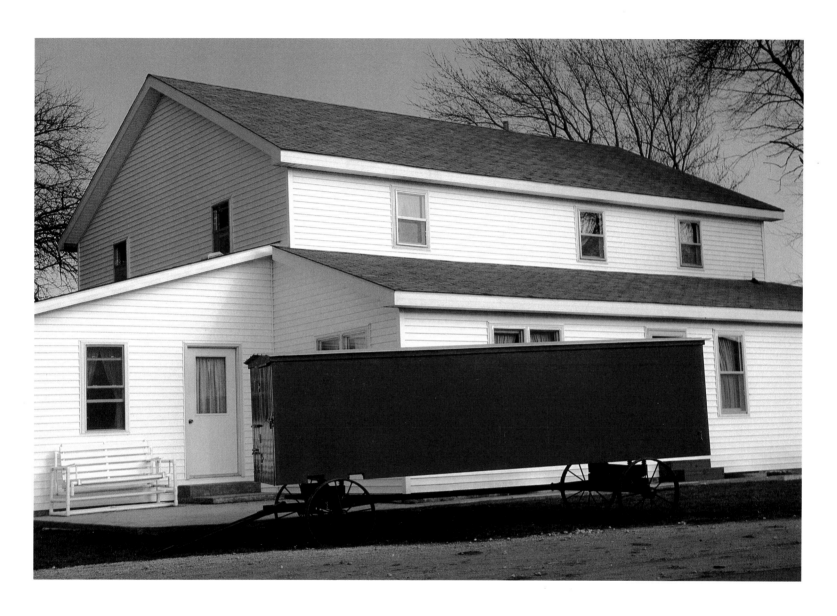

*Wagons, such as the one above, are used to transport benches, dishes, and other items necessary for
Sunday worship and the large meal that is offered afterward. Following the service the
wagon will be packed up and pulled to the next home.*

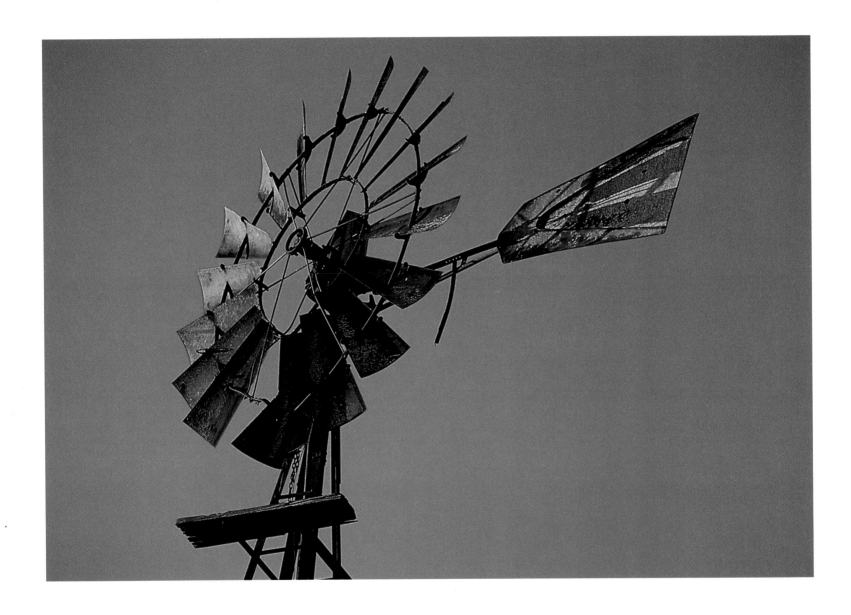

Windmills are still a familiar sight on Amish farms. In some communities Amish men earn a living manufacturing and repairing these landmarks of traditional rural culture. Standing tall in the light of late afternoon, this windmill provides an efficient and practical means of pumping water.

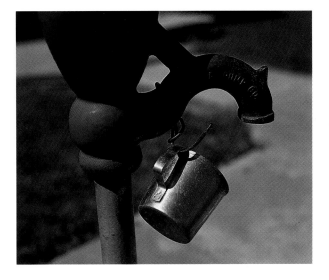

Most Amish yards have a hand pump, complete with a tin cup. Once the pump is primed, one can crank the iron handle and draw up a cold, teeth-numbing drink of water on a scorching August day.

This telephone shed is situated along a country road. Several Amish families share the phone, which is close enough for emergency and business calls, yet sufficiently inconvenient for personal conversations. Phones are not allowed in homes, which encourages visits to friends and neighbors rather than phone calls.

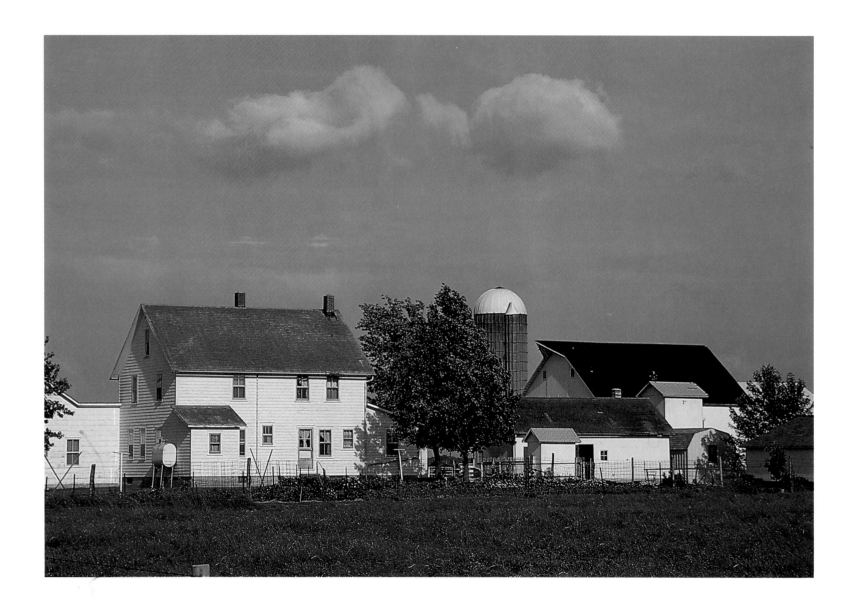

The Amish do not enter nursing homes or collect social security. Instead, when they retire aging parents move in with
their children and into a grandfather's, or Grossdadi, house, which is often attached to the main house.
Here, they will be able to help out on the farm and be cared for by their children.

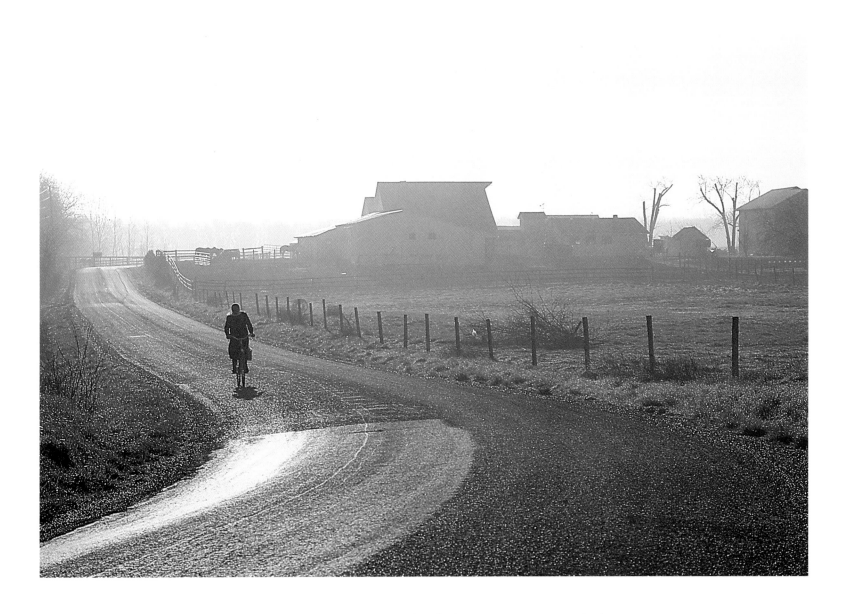

*In some communities the Amish have come to value the bicycle as a means of transportation, as evidenced
in this photograph of an Amish woman peddling along. In the yellow light of dawn the
asphalt glistens along a country road that winds past an Amish farm.*

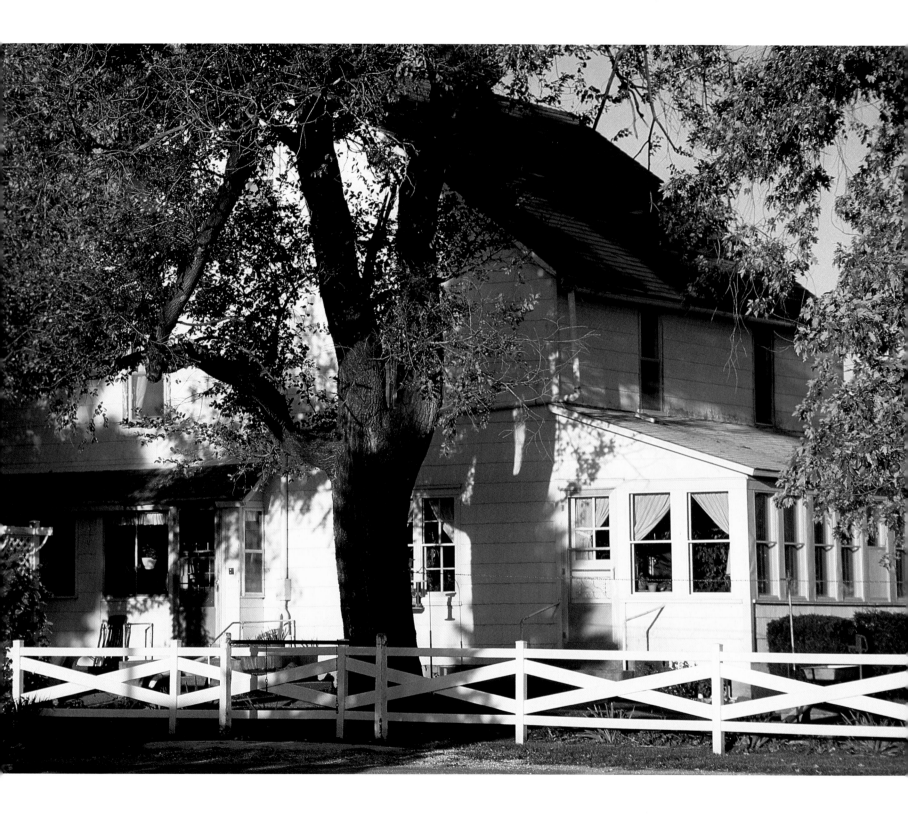

Yards

AMISH YARDS ARE silent except for the creak of the windmill and the flapping of laundry on the clothesline as men, women, and children go about their work for the day. Children are introduced to chores around the house and farm at an early age, generally when they are about six years old. Work is viewed as a positive experience through which children may contribute to the family.

Because they are able to raise most of their own food, the Amish enjoy the abundance and the independence of rural life. Tended by Amish women, with the help of the younger children, their large vegetable and herb gardens are meticulously free of weeds. Through trellises and flower gardens, Amish women add many aesthetic touches to their yards, which are neatly kept and occasionally surrounded by a white fence.

Orchards may include apple, pear, and cherry trees. Many Amish raise strawberries and raspberries as well, but apples are a preferred fruit, perhaps because they are so versatile. Apples store well and are readily transformed into apple sauce, apple butter, and apple cider. A few Amish keep hives of bees.

The Amish often butcher their own cattle, pigs, and chickens for food. Every year Amish women store huge amounts of meat in propane freezers, often renting locker space in town. They also "put up" bushels of produce for the winter, filling the shelves in their cellars with jars of peaches, green beans, and other fruits and vegetables.

Families purchase only staples, such as flour, sugar, and coffee, at the grocery store. They may spend as little as $25 every two weeks for a family of seven or more children. Amish women are often amazed at how much their "English" neighbors spend on groceries.

It is not all work around Amish homes. A volleyball net may be set up in the large yard, and late in the afternoon, or on the Sundays reserved for visiting, one may observe a rousing game in progress. With their emphasis upon family and community, the Amish prefer group games—the two favorites being volleyball and softball. Both girls and boys enjoy these games, which are undertaken in a spirit of laughter and good fun. Absent from their games is any hint of the intense competition that now characterizes American sports.

To add a touch of color to their yards Amish women also plant a few flowers here and there. Because of the admonitions against anything "fancy," women are a bit hesitant in their efforts, restricting themselves to a few day lilies by the house, a little border of marigolds around the vegetable garden (which also serve the practical purpose of discouraging rabbits), and perhaps a clump of petunias by the back door. They mostly plant annuals that will die off at first frost. �֍

An Amish home gleams white in the soft light and long shadows of a late afternoon in the country. Amish homes are typically plain and very well-kept. Sometimes, they are set off from the road by a plain wooden fence.

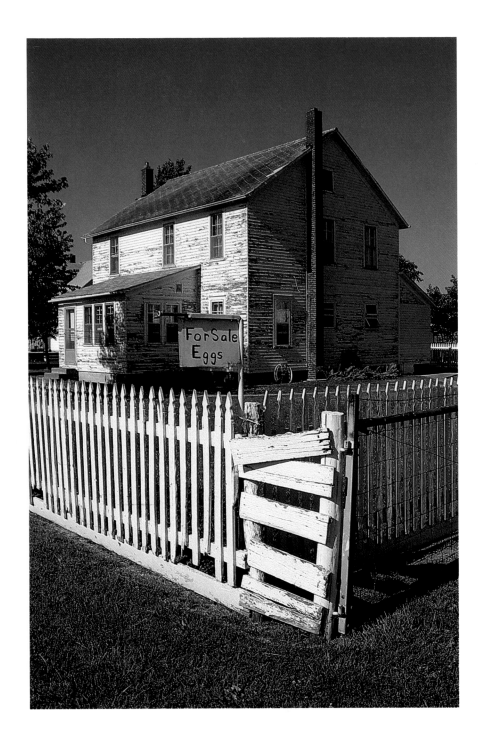

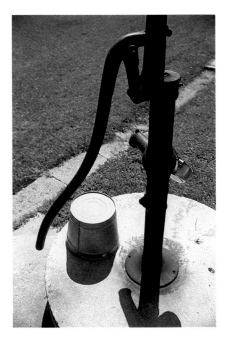

Hand pumps may also be used to draw up buckets of clear, cold water for thirsty chickens or to get young tomatoes in the garden off to a good start.

Sometimes the Amish sell eggs and other produce, as well as handicrafts, directly out of their homes. Although it could use a coat of paint, this house is typical of the traditional white clapboard farmhouses in which many of the Amish live.

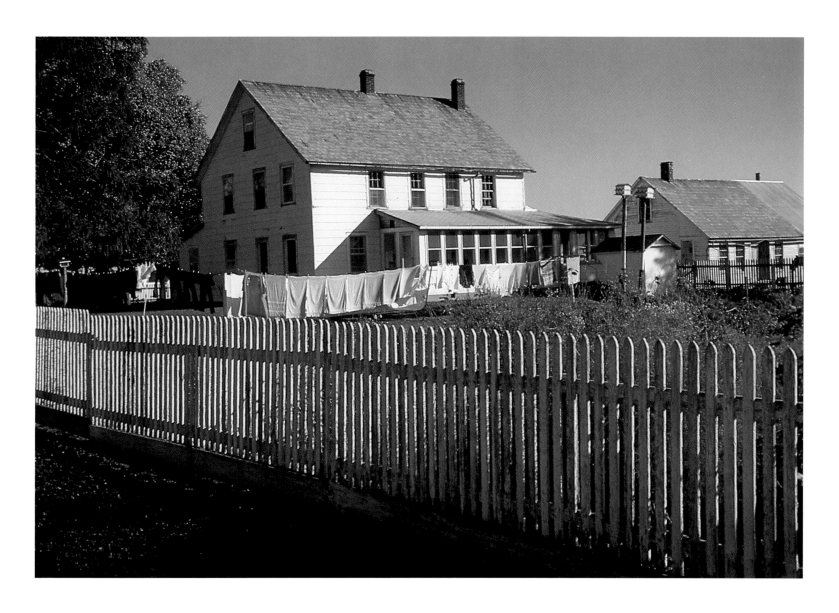

*A picket fence, large vegetable garden, and martin houses complement the wash on the line
at this pleasant Amish home. It is typical of those in Amish communities across the United States.*

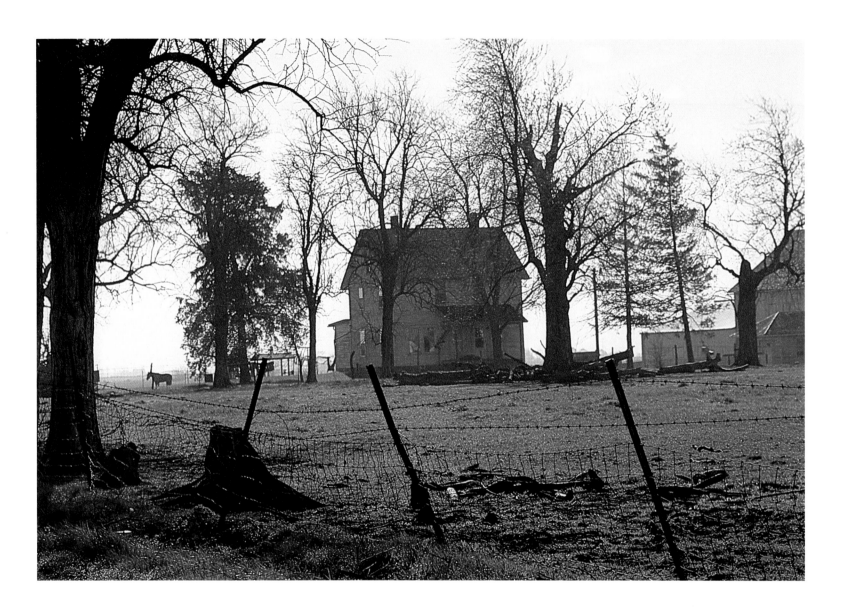

An Amish home appears to shimmer in the haze of early morning while horses graze in the distance. Amish country is typically distinguished by a sense of peace and tranquility that the Amish refer to as Gelassenheit.

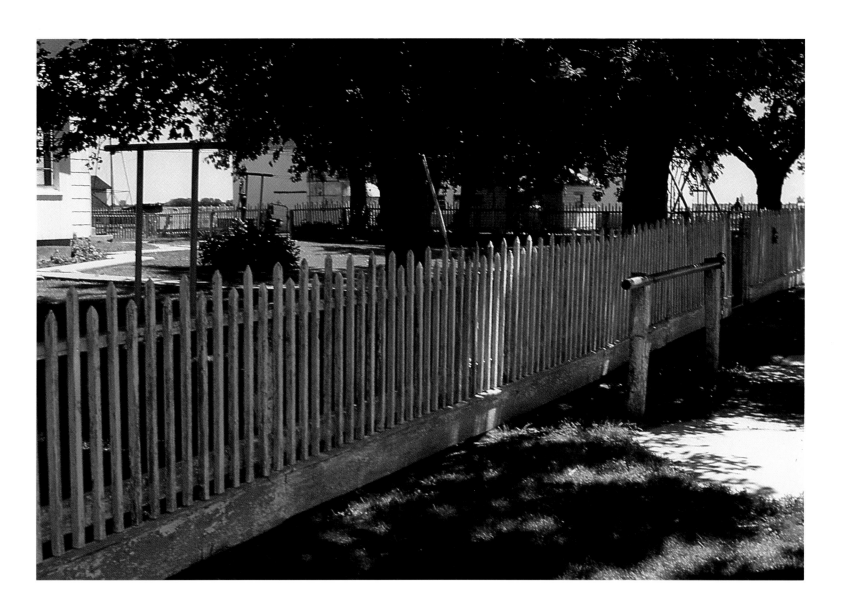

Along with the picket fence, the clues that this is an Amish yard are the clothesline and the post for hitching horses in the shade when friends, neighbors, and relatives come visiting.

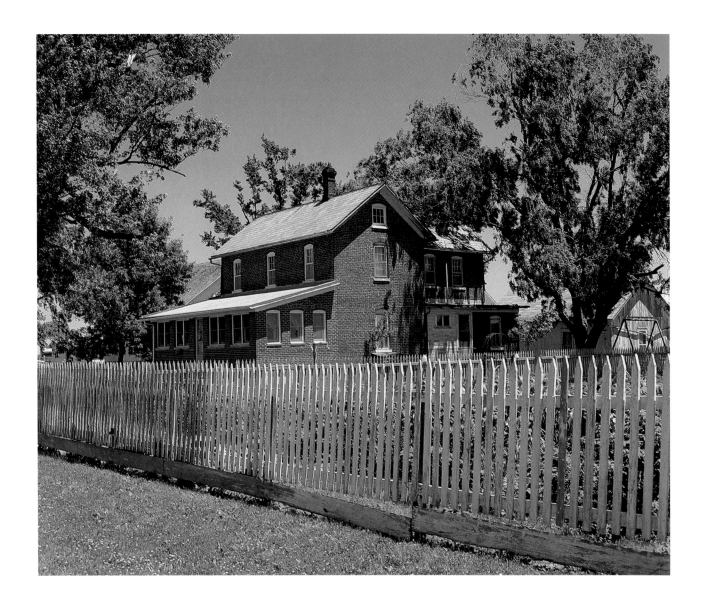

Like other pioneers, the first Amish to come to America built log cabins and then stone, brick, or woodframe homes. This brick home is somewhat unusual for the Amish of the Midwest, but still is situated in a tidy yard and set off from the road by a picket fence.

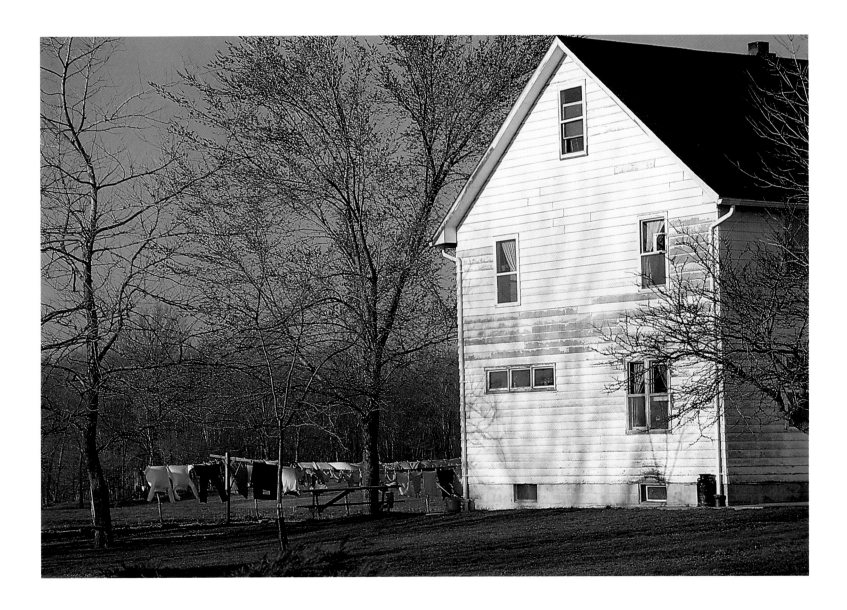

*On wash day, brightly colored clothes may be seen flapping in the breeze most
everywhere in Amish country. On windy mornings the clothes quickly dry and are imbued
with that fresh scent and feel that is carried on the air of a spring day.*

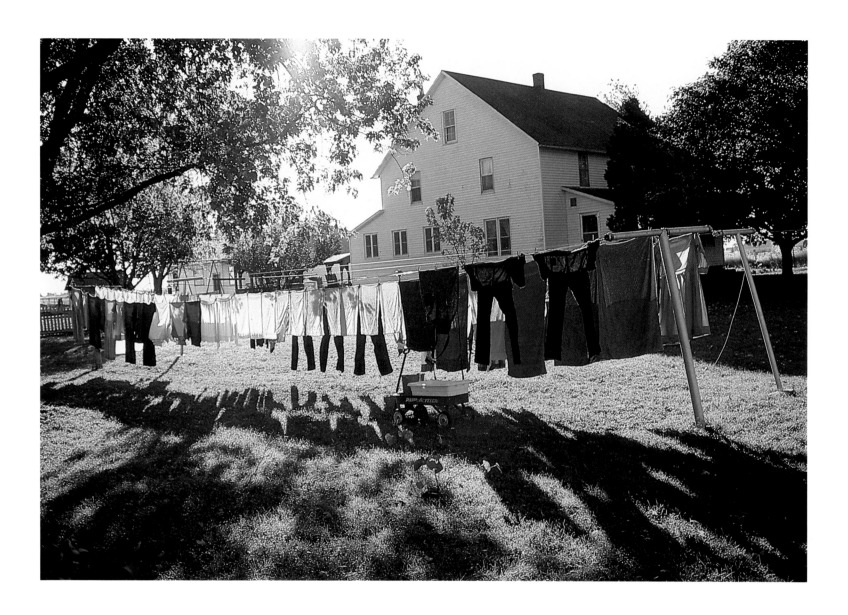

*A blend of black and vibrant colors, the morning wash is silhouetted against the glint of the
sun in the front yard of this Amish home. Not long after sunrise, women already
have their laundry on the line.*

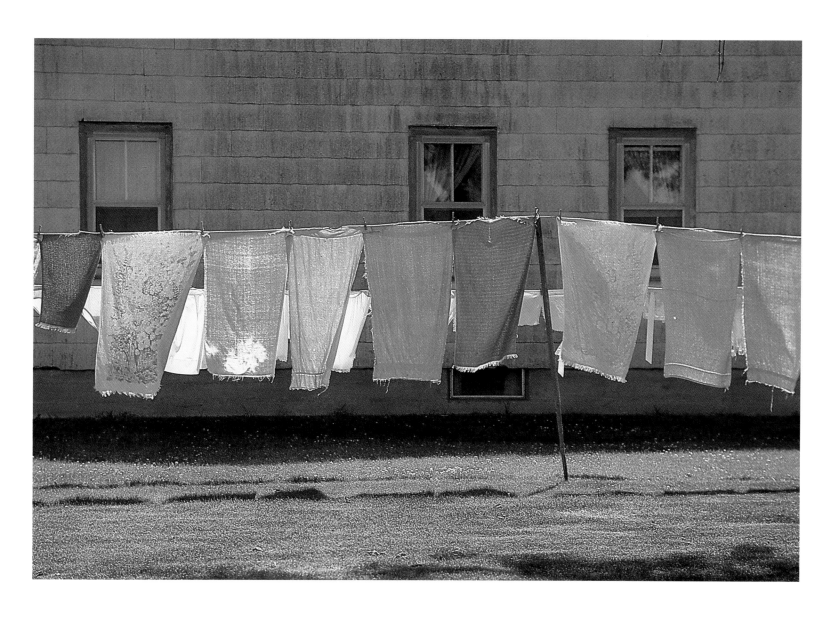

*These towels catch the light as well as the breeze. While some Amish may use gas-powered dryers,
most prefer to let their wash dry outside in the fresh air.*

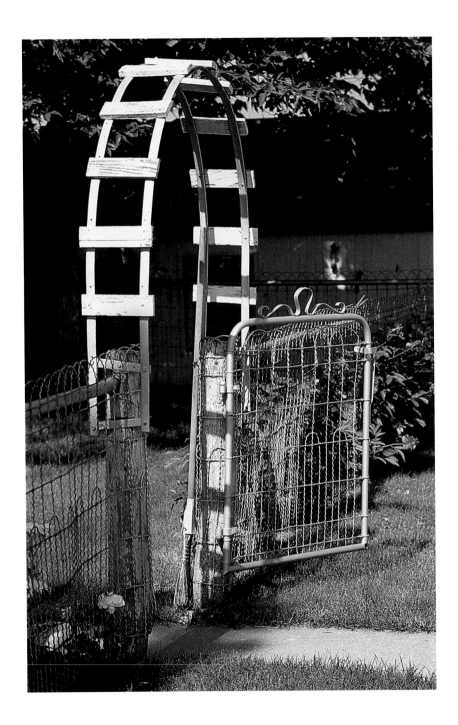

An important feature of Amish yards is the sprawling vegetable garden in which one rarely, if ever, encounters a single weed. Because Amish families average seven or more children, the girls and women put up enormous amounts of vegetables for the winter.

Amish women often plant flowers in their yards—usually annuals. With flowers adorning the fence, this arched trellis indicates the entrance into the yard of an Amish family.

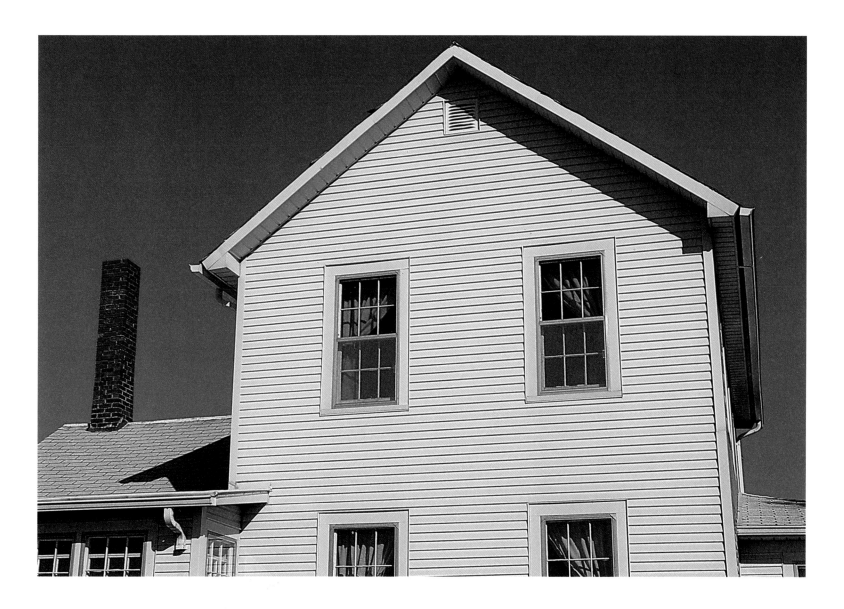

*On a clear summer day, these curtains appear as deeply blue as the sky overhead. They are even
more striking when set against the plain trim and glistening white clapboards
of this Amish farmhouse.*

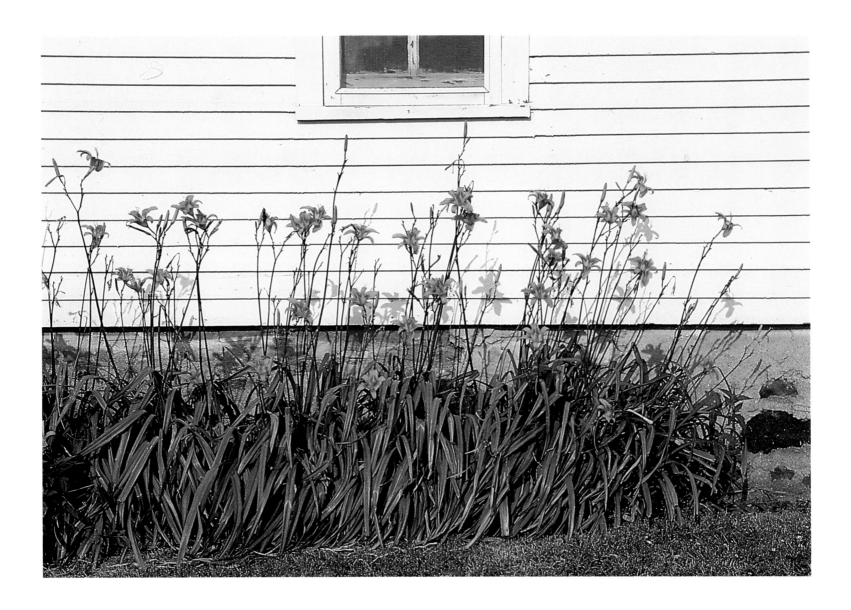

Although dedicated to "plain living," many Amish women admit touches of beauty into their lives in the
form of flowers and modest yard ornaments. These may be as basic as a clump of day lilies planted at the
side of the house, where their orange trumpets extend to the light.

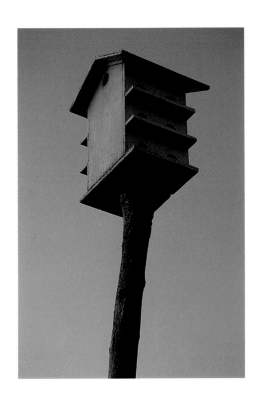

Although not unique to the Amish, martin houses are typical of the practical manner in which they manage their farms. The birdhouses attract martins that in turn devour large numbers of insects that would otherwise damage crops in the fields and gardens.

The martin house is mounted atop a tall pole to make it more attractive to the birds and to discourage predators. This birdhouse is silhouetted against the hazy sun at the end of a humid August day.

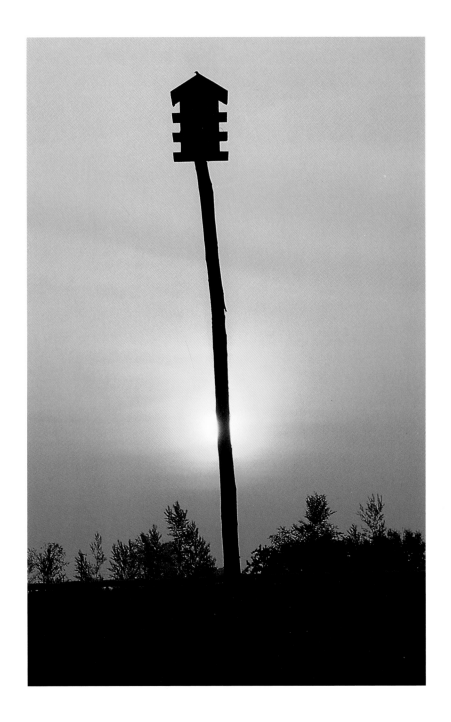

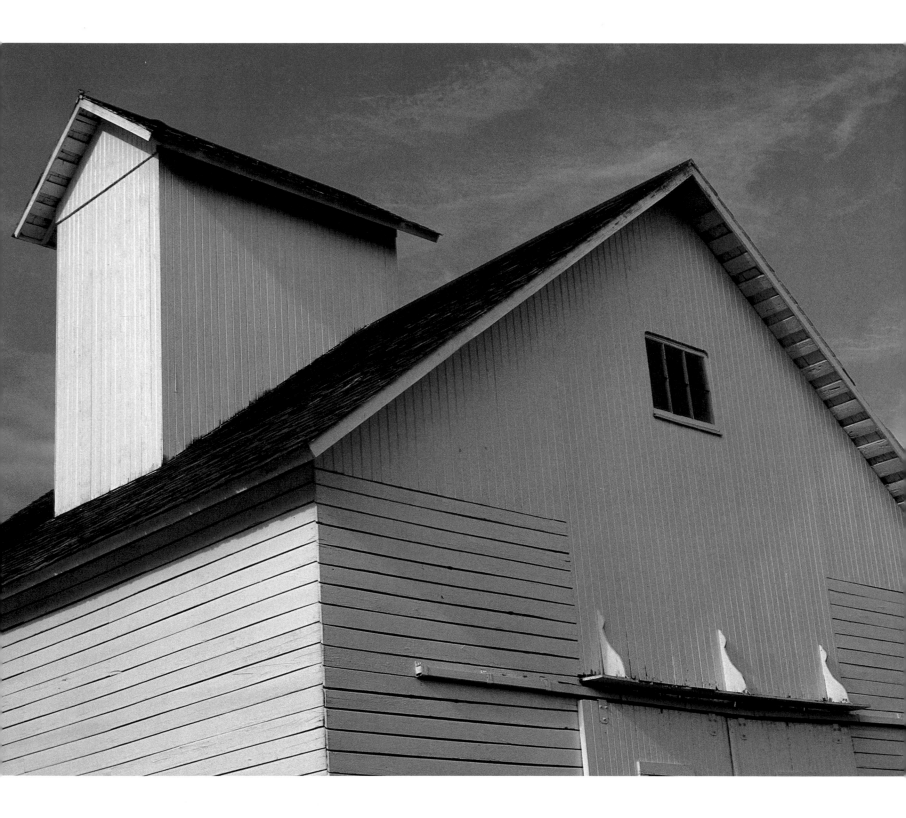

Barns & Horses

BARNS ON AMISH farms consist of a network of sturdy hand-hewn beams sheathed with wide planks. During barn-raisings, which have come to represent the spirit of Amish cooperation, craftsman swarm over the structure, building in a single day a barn that may last for generations. Within the barn are stalls for horses, a loft for hay, and sometimes a milking parlor. The barns differ from others in the area perhaps only in the clumps of harnesses hanging on the wall. Many hand tools and older agricultural implements no longer used by "English" farmers are also stored there.

The barn, along with a corn crib jammed full of bright yellow grain, the lean-to chicken coop, and other outbuildings on Amish farms, appears old-fashioned, especially in contrast with the long metal buildings and huge tractors, combines, and other machinery sitting in the yards of nearby modern farms. Other farmers do not store grain on their farms because they keep so few, if any, livestock, whereas the Amish still have highly diversified farms.

The Amish also rely upon hand pumps to water livestock and to wash up after a hard day in the fields. Many Amish use windmills to pump water, and a few men make a living by manufacturing and repairing these whirling landmarks of traditional rural life.

Buggies are seemingly everywhere in Amish country, outnumbered only by the horses grazing in pastures, congregating in barnyards, and lounging in the shade of trees along the fence line. If they are sleek animals with slender legs and delicate hooves, the horses are likely Standardbreds used to pull buggies. These horses are often retired harness racers, and the Amish—especially the youngsters—allow themselves to take a little pride in the grace and spirit of these horses. Most Amish keep one or two driving horses.

If broad and powerfully muscled with large, plodding hoofs, they are draft horses—usually light brown Belgians or dapple grey Percherons—relied upon for heavy work in the fields and to haul grain to market. Amish farmers often have teams of six to eight of these gentle horses. The may use tractors in their farmyards as power sources to grind feed and to fill cribs with ear corn, but they never use them in the fields.

The Amish choose not to utilize tractors for fieldwork because of the high cost of equipment and fuel. The also point out that horses naturally replace themselves while new tractors must be purchased every few years. Higher production costs would require expanding their farms, often at the expense of their neighbors. By keeping their overhead low, they can get by on smaller farms and live closer to each other.

During the spring, Amish men competently guide their teams over the fields, laying open furrows of black soil, harrowing out the lumps, and planting their crops. Horses are also relied on for cultivation and harvest of corn and other grain crops, as well as for baling hay and straw. ✻

The Amish are widely admired for the cooperative manner in which they raise barns. Excellent craftsman,
they construct buildings in a single day that prove useful for generations. Impossible to overlook on
Amish farms are these plain, yet lovely, structures.

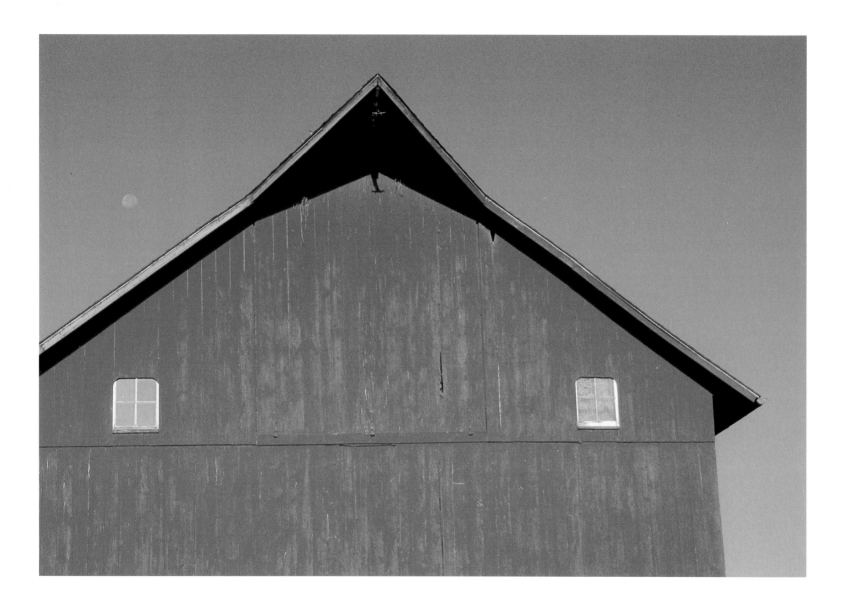

*Depending upon the region, Amish buildings may have basic angled or gambrel roofs. Barns are typically painted
white or red. Ordinarily, red is a taboo color among the Amish, but is allowed on barns supposedly
because red paint is more economical than other colors of paint.*

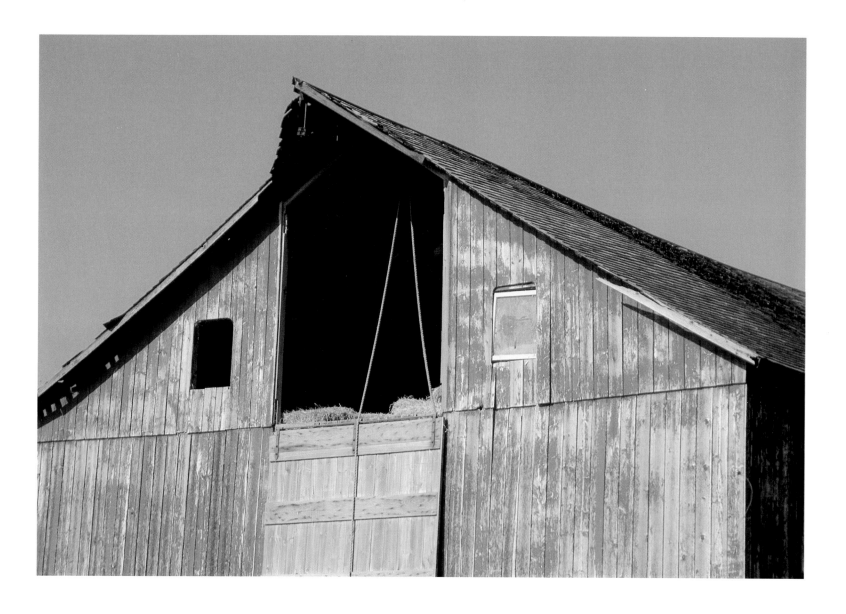

Amish barns have spacious lofts in which large amounts of hay are stored to feed livestock through the bitter months of winter. The loft door is dropped open in this barn so that the heavy bales of hay may be more easily tossed into the barn and stacked to the rafters.

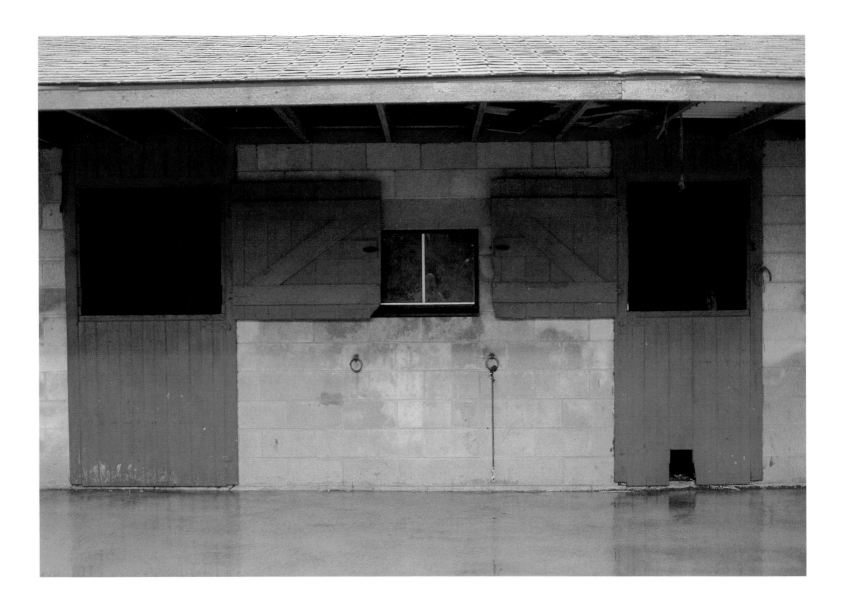

*This horse barn sports Dutch doors painted a glistening red. It is somewhat unusual to see such a bright shade
of red anywhere in Amish country, but the style of doors is common and very practical when one
is looking after horses. The floor of the barn has also been thoroughly washed down.*

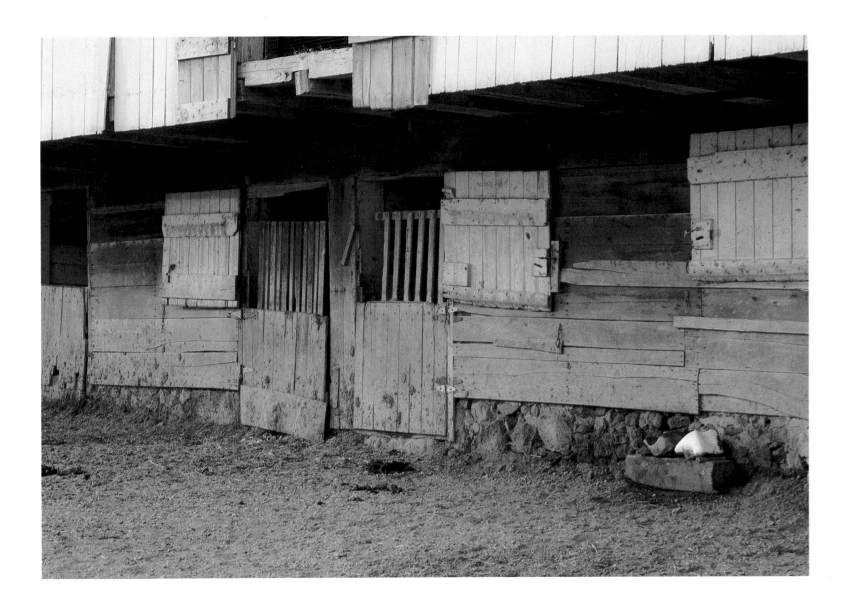

*The lower level of this hundred-year-old barn shelters the livestock while equipment is stored on
the level above and bales of hay are packed into the loft. Virtually every square foot of
the barn is productively utilized.*

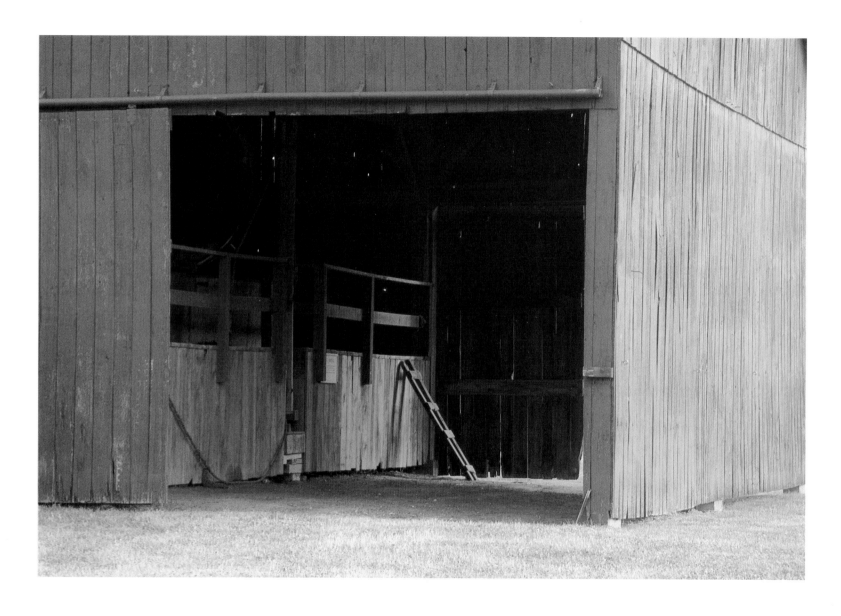

The large doorway of this barn permits Amish farmers to pull a load of hay directly inside to facilitate unloading and stacking the bales. Loads of hay may also be quickly pulled into the barn in the event of a sudden, late afternoon thunderstorm.

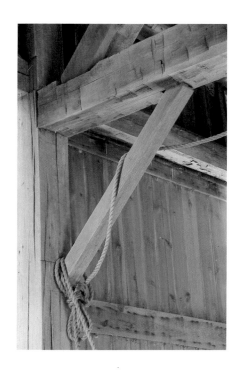

Each of the beams on this nineteenth-century barn was handhewn with a broadax or adz. The joints were then painstakingly chiseled out so that the timbers, including many braces, fit together perfectly.

The timbers on this Amish barn provide maximum strength to the framework of the building. The barn is then covered with wood plank sheathing. The louvered windows provide ventilation, but keep out the rain.

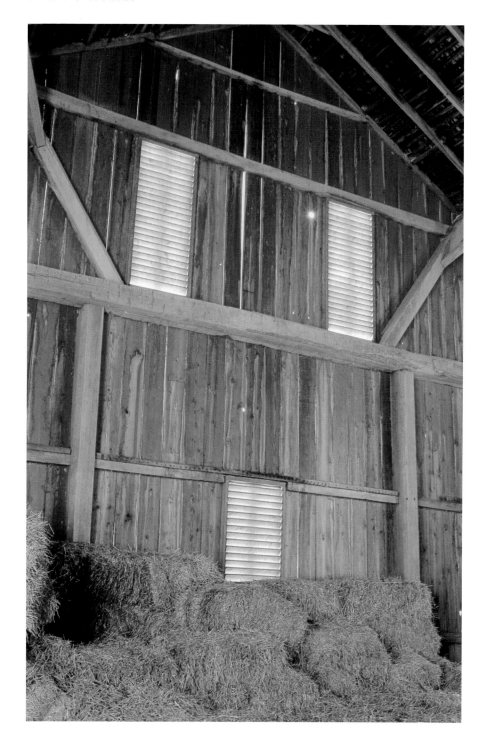

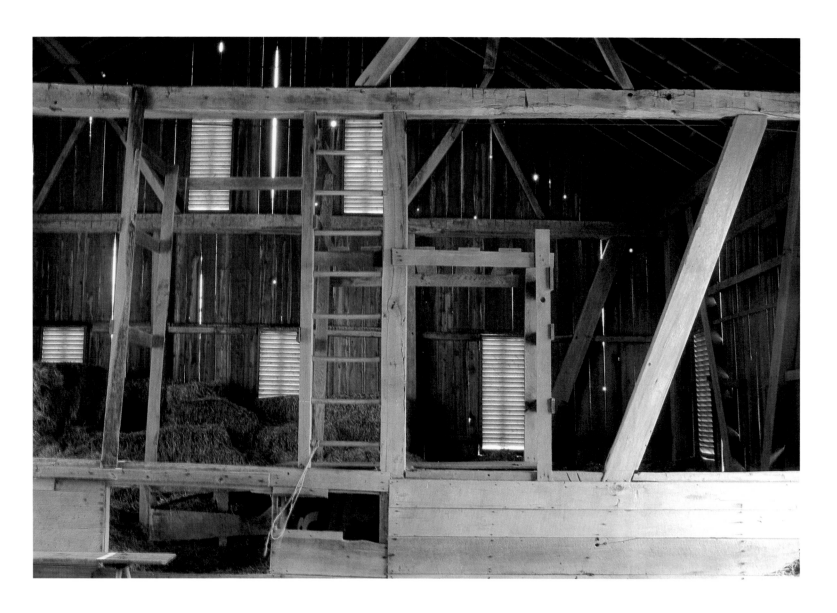

This network of timbers illustrates how traditional barns are designed to provide both strength
and capacity to accomodate voluminous amounts of hay. Designs for Amish barns
have been passed down for generations.

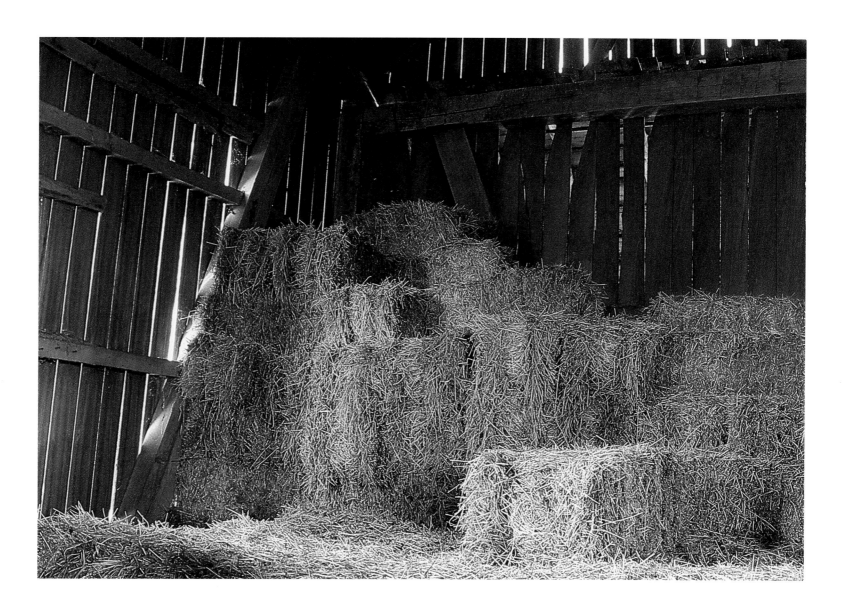

*The aroma of freshly baled hay fills the interior of this Amish barn. The Amish once
pitched loose hay onto horse-drawn wagons that lumbered to the barn, where the
clover and alfalfa was stored in the loft.*

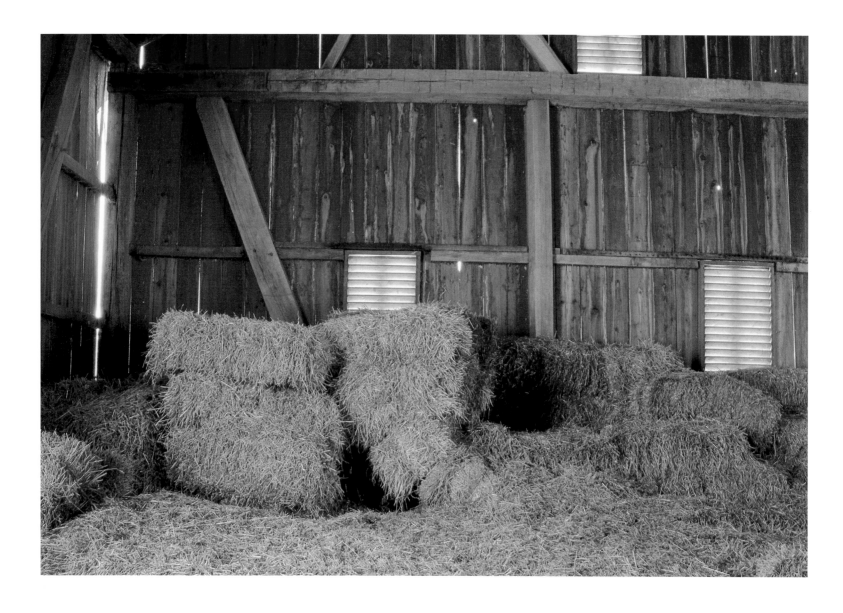

*Using machines pulled by horses, Amish farmers now bale their hay. With workhorses,
driving horses, cattle, and other livestock, the Amish must put up large amounts of
hay to get them through the long winters.*

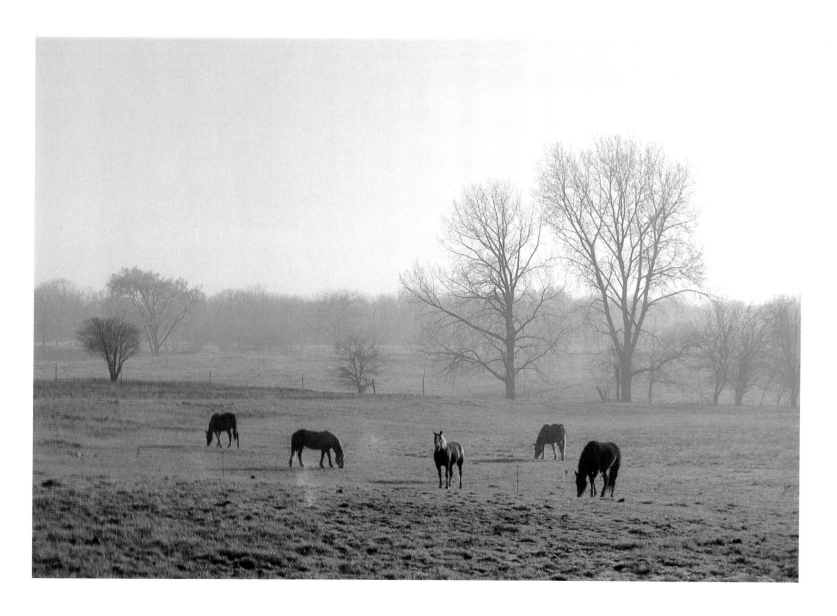

These horses are grazing in the haze of early morning. Unlike modern agribusinesses that
alternate cash crops, a considerable portion of Amish farms is given over to
pasture for horses and cattle.

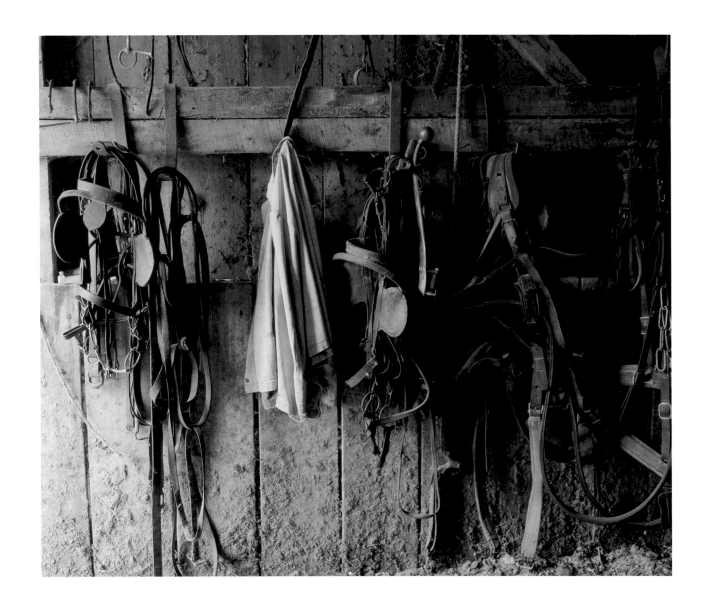

Amish barns are further distinguished from other barns by the clumps of harnesses that hang from the inside walls. These harnesses, along with a faded blue workshirt, catch the soft light of early morning through an open doorway.

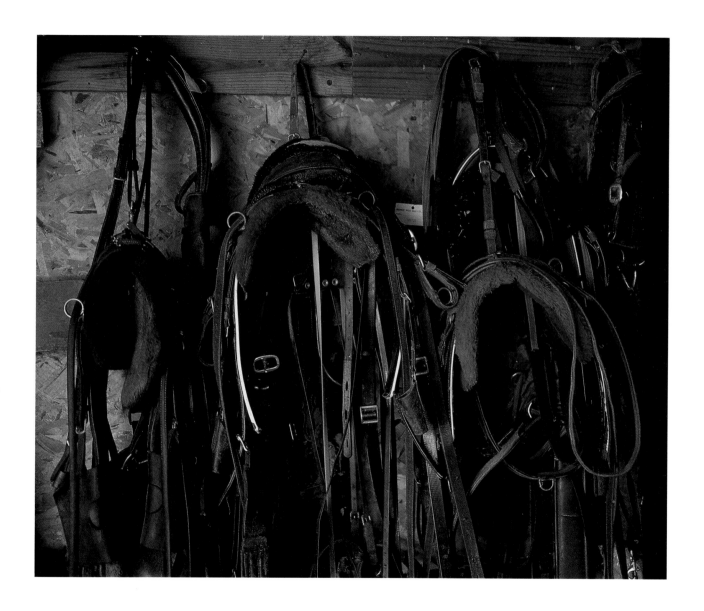

Different harnesses are used for draft horses and for horses that pull buggies. Because of its
bright colors, this harness hanging on the wall of an Amish barn is considered "fancy"
and is reserved for special occasions.

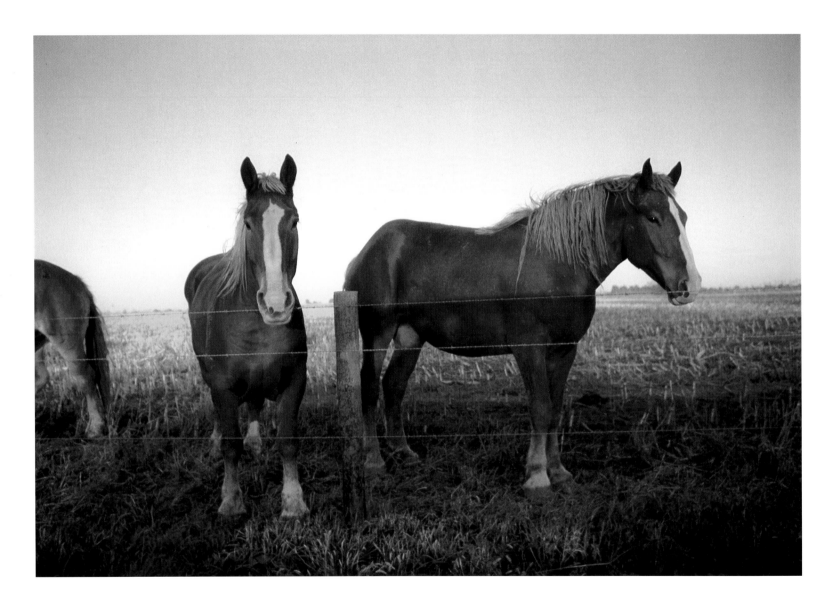

Draft horses are immense animals—especially when one is standing next to them—yet they are typically very gentle and friendly. From an early age Amish boys learn how to handle these work animals.

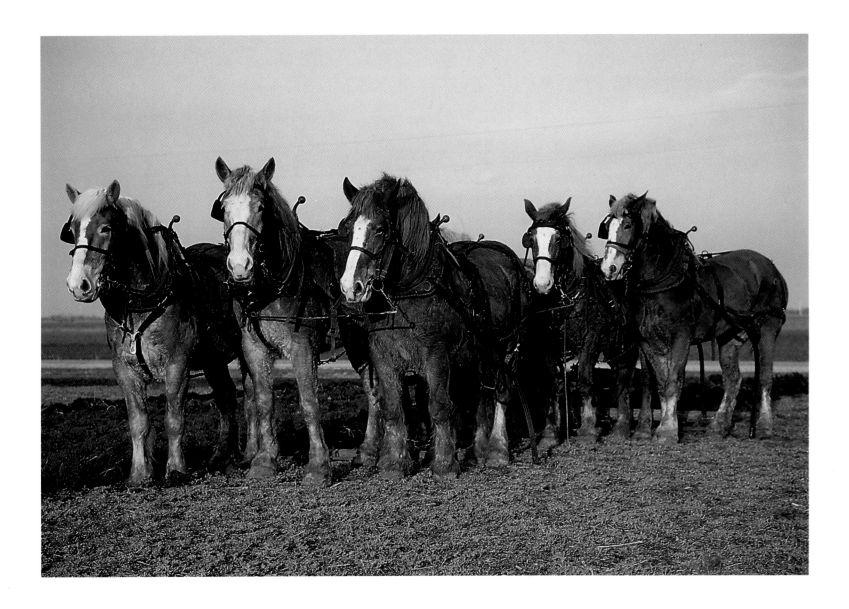

Horses are seemingly everywhere in Amish country. These powerful animals are being rested by
a young farmer who was concerned about the difficulty of plowing wet
ground on an April afternoon.

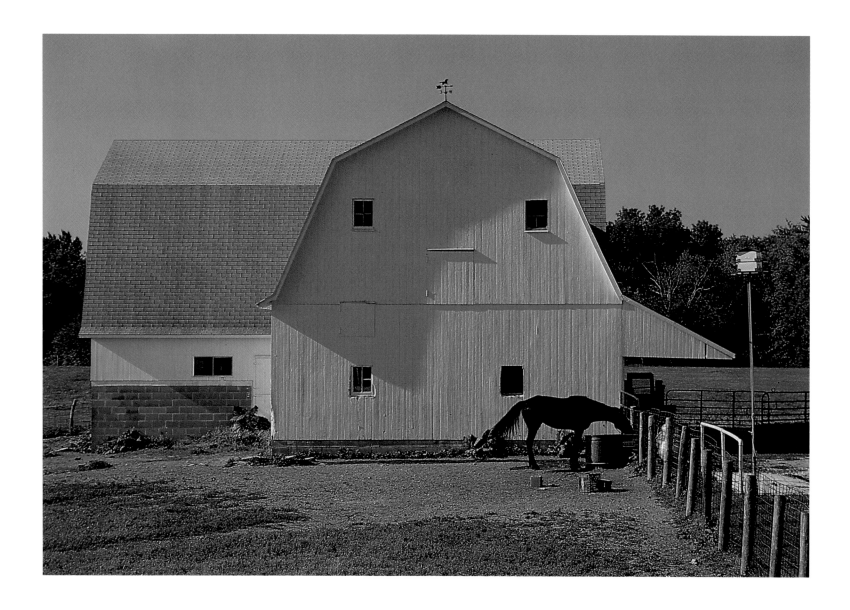

Horses work hard and in return are well cared for by the Amish. This driving horse has been
let out to pasture next to the barn on an Amish farm. The birdhouse lends
an additional touch of charm to the rural scene.

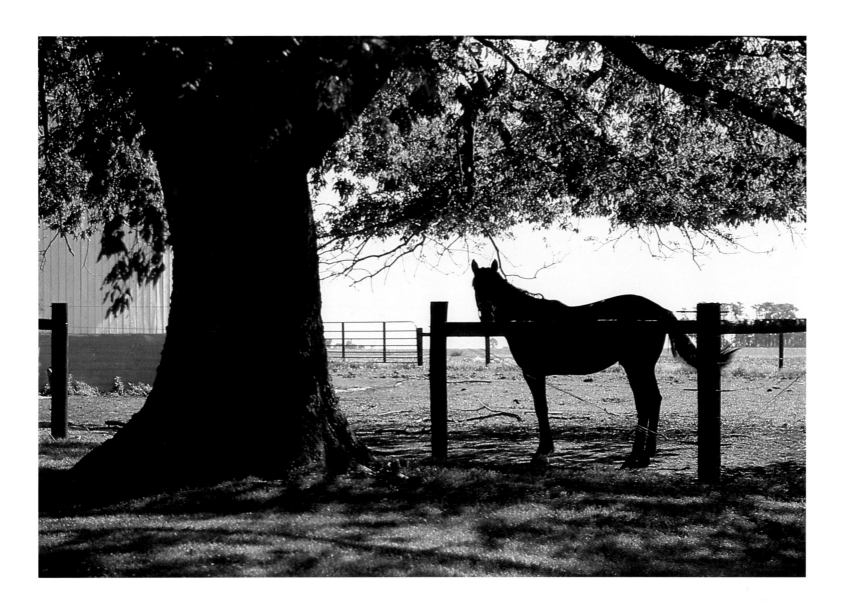

Silhouetted against the glint of the August sun, a driving horse lounges in the shade of a tree.
Often retired harness racers, these horses are used to pull buggies. An Amish family may
own one or two driving horses.

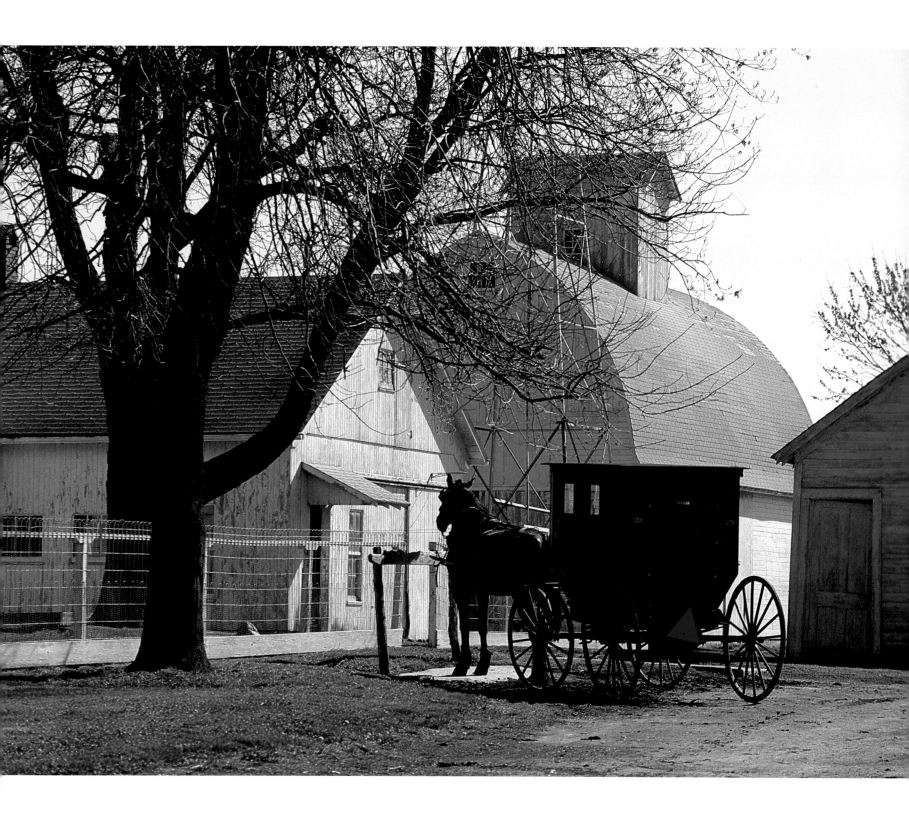

Buggies

BECAUSE THE AMISH cannot travel great distances in their buggies, their lives center upon their small rural communities. Being together as a family and a community is basic to their way of life. The Amish cherish their families and neighbors, and visiting allows them to keep in touch. Settlements are organized geographically into church districts, called *Gemeindes*, with about 75 baptized adult members. All of the families in the church district live close to each other—basically no farther than a horse and buggy can comfortably travel to services. Because the Amish do not have church buildings, services are conducted on a rotating basis in Amish homes. Every other Sunday the Amish gather in a different home to worship, with the alternate Sundays reserved for visiting friends and relatives.

Many Amish do travel beyond the limits of their *Gemeindes*. They will hire a driver for a car or van or take the train or bus to visit relatives and friends in other Amish communities. Or they may simply go on a sight-seeing tour, in much the same manner as other people go on vacation, although they prefer to visit museums and zoos, in which they find some educational value and not simply amusement.

Whether parked in the farmyard, tucked away in a barn, or rounding a corner on a rural road, the buggies offer visible proof that the Amish are unlike the "English." By continuing to drive their buggies, the Amish have prevailed in separating themselves from modern society and in continuing their traditional way of life.

Buggies are made in a basic, squarish design, symbolizing the lack of pretension in the lives of the Amish. Their bases and frames are now con-structed of fiberglass, which is more durable than wood. Innovative features are often added, such as vinyl tops, ball-bearing wheels, hydraulic brakes, battery-powered windshield wipers, and thermopane windows, as well as carpet and upholstery in several different colors. Fluorescent triangles and reflector lights are mounted on the back for safety. Despite these modern "options," the basic design has remained unchanged for over a hundred years.

Costing about $3,000, buggies are made by Amish craftsmen in shops on their farms. It may take ten days to build one, but if properly maintained, the vehicles will last for many years. A father often purchases a buggy for his son when he turns sixteen, and the young Amish man may never need another one for the rest of his life.

Some teenage boys go through a rebellious period called "rumpaspringa" which literally means "jumping around" or more loosely "running around." They may outfit their buggies with additional plastic reflectors, stereos, carpet-ing, dashboards, and speedometers. With a good horse, buggies may travel 12 miles per hour. With an older horse they may average only 10 miles per hour. "If you ever clock one doing 15 miles per hour," one Amish man quipped, "you can be sure it's a teenage driver."

The Amish in Pennsylvania drive gray buggies while Amish people living in the Midwest prefer black buggies. People in one settlement have decided to drive buggies with white tops, and a community in Indiana prefers open buggies. These are only regional differences—variations on the theme of "plain and simple" living among the Amish. ✷

Visiting is basic to a sense of community among the Amish and buggies may be seen parked in farmyards everywhere as friends, neighbors, and relatives stop by to say hello or bring some news.

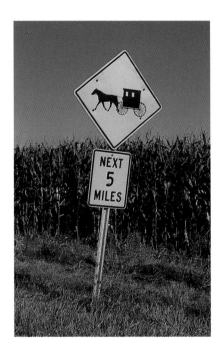

Amish communities have become prime tourist attractions. The sign above notifies motorists that they are entering Amish country and that they should be on the lookout for buggies moving slowly along the road's shoulder.

Parked in a barn, this buggy offers just a glimpse of the Amish way of life through the doorway. Despite their traditional design, buggies are now required to be outfitted with orange triangles and reflectors for safety on the roads.

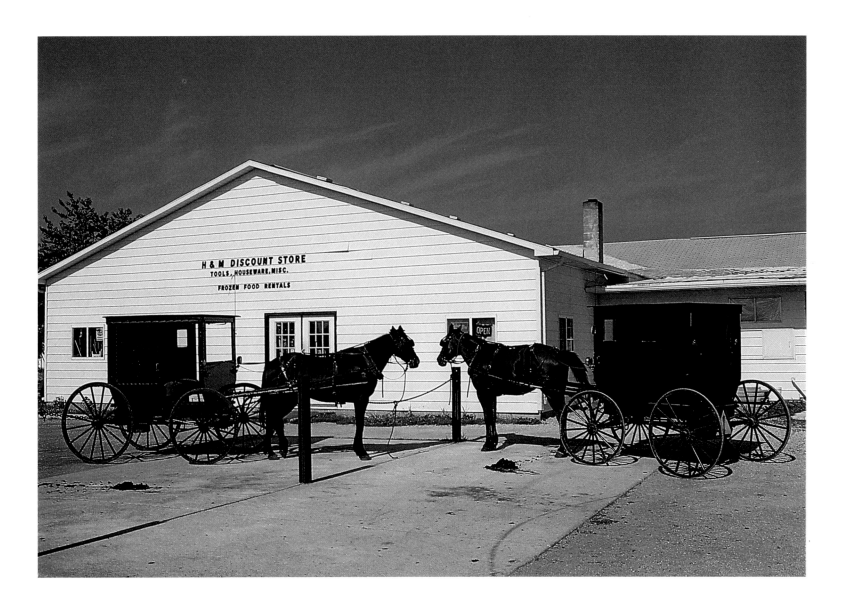

*These two horses appear to be having a conversation while their drivers are shopping inside this
Amish store. Catering to both the Amish and the "English," such businesses
are scattered throughout Amish country.*

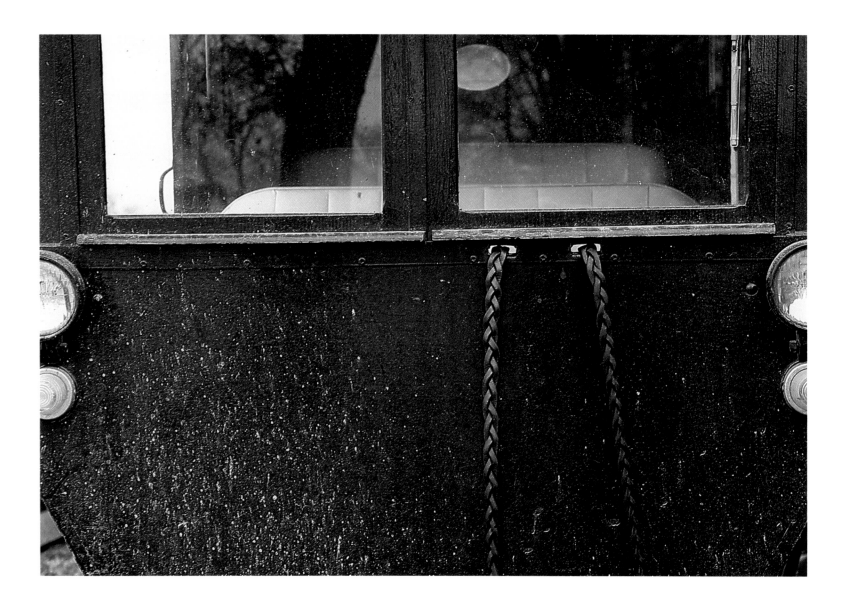

With reins inserted through the front, this buggy is mud-splattered from its
frequent trips along the country roads. Buggies are equipped with many conveniences,
including windshield wipers.

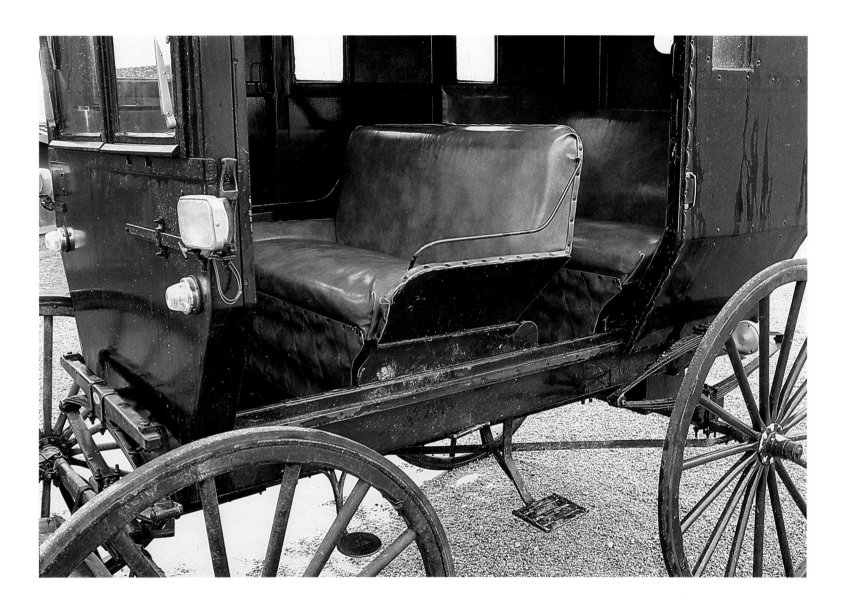

As long as they follow the accepted plain and simple box-like design and
are painted black, Amish buggies may be outfitted with upholstered seats, heaters,
battery-powered lights, and other modern comforts.

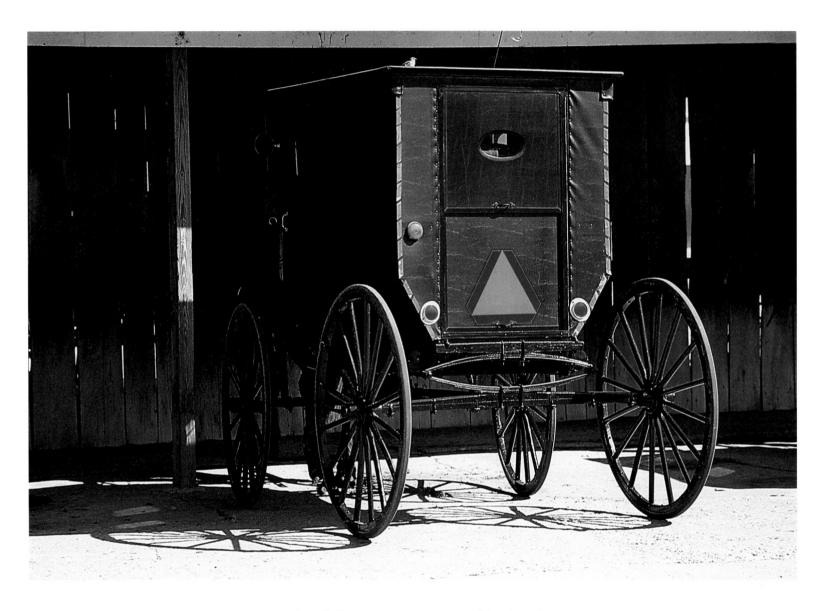

In this small village, an open "garage" of sorts is provided for the Amish.
Horses may be hitched in the shelter, which provides relief from both the sun and
the rain while the Amish go about their business for the day.

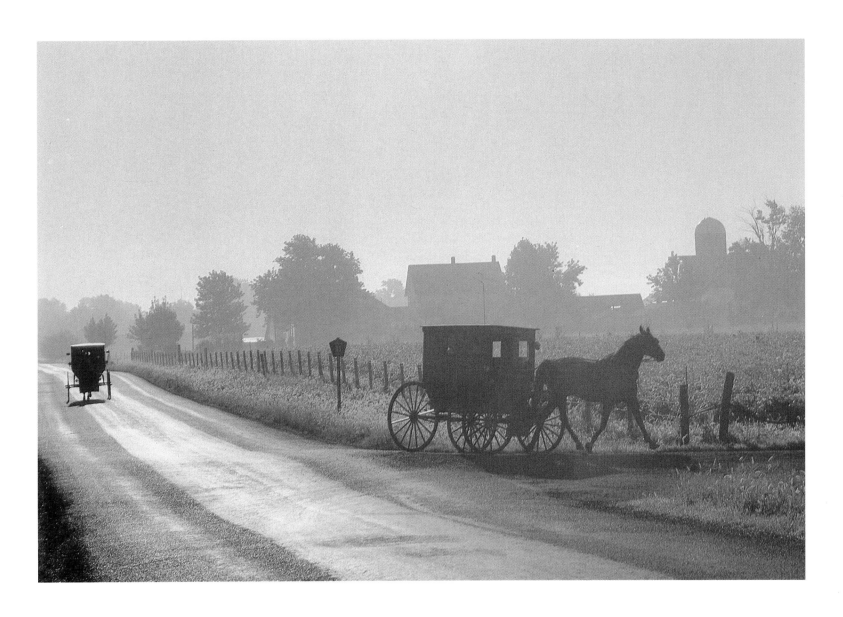

Rounding a corner, this horse and buggy are on their way to a neighboring farm.
Although it is just a few minutes after sunrise, many Amish are already busily making their
way along the country roads.

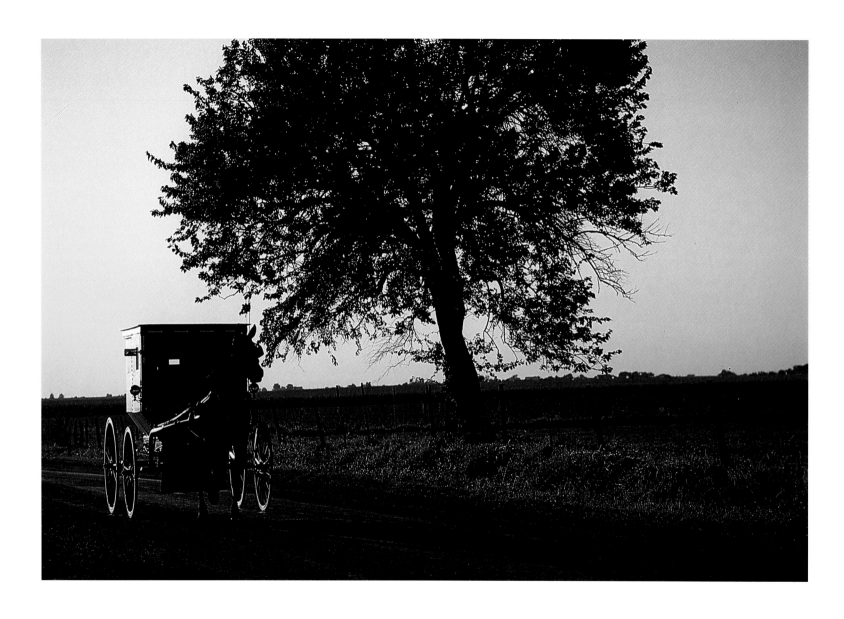

Late in the afternoon the Amish are still going about their business in town or visiting friends
down the road. They may not return from their visit until well after dark.

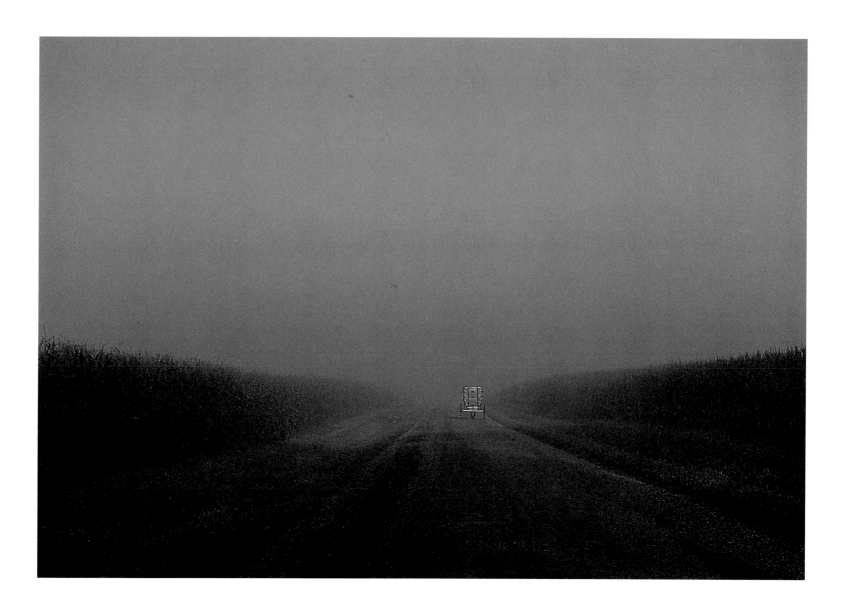

*Seeming to emerge from the white mist, this buggy is briefly caught in the sun as
it makes its way along a country road with fields unfolding on either
side and the prairie sky towering overhead.*

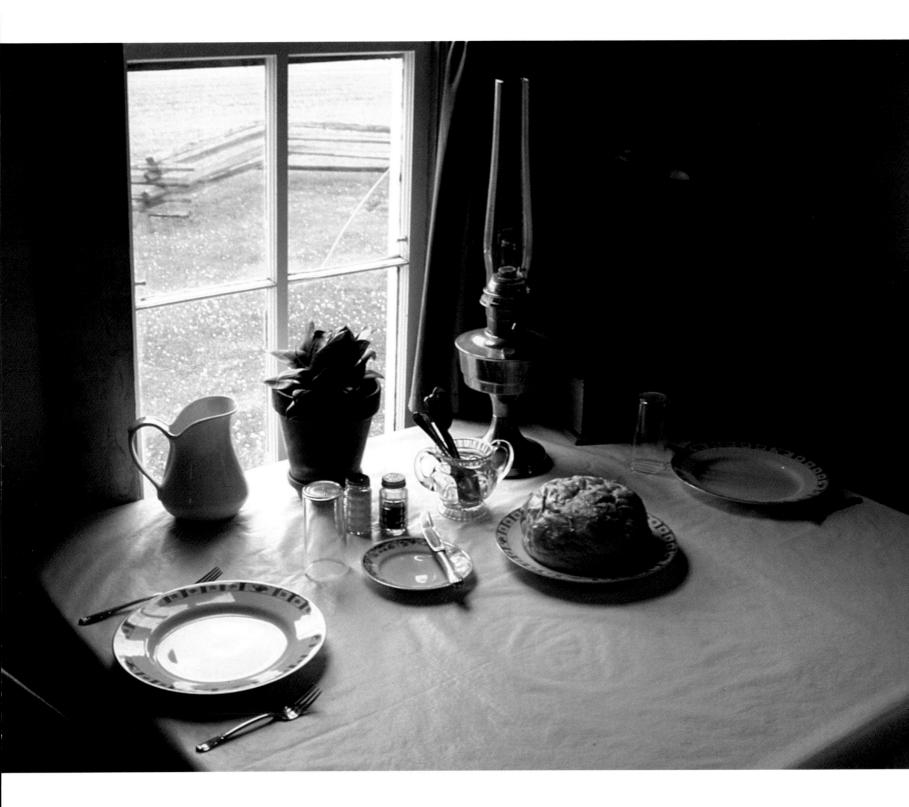

Homes

WHEN WANDERING ALONG the back roads in Amish country, one is continually struck by what is *not* there. No utility lines are strung to the houses because the Amish do not have electricity or telephones in their homes. They choose to use diesel generators to produce electricity for woodworking and other occupations but they never use it in their personal lives. They believe that radio and television, so common in modern society, would threaten the family life that they value so deeply. If they were to permit electronic media in their homes, these gadgets might replace the family as the center of attention. As one man described his non-Amish neighbors, "They're home together, but they're not sharing anything."

Instead of sitting in front of the television, the Amish read books and periodicals. Many Amish visit public libraries and families typically subscribe to several magazines and newspapers, including *The Budget*, containing news about settlements across North America. Through letters and visits, the Amish keep in touch with distant friends and maintain contact with a large, extended family. Their families are stable, with few divorces.

The Amish are permitted to use their neighbors' phones, telephone booths, or community phones set up in wooden sheds at some rural crossroads, but they do not have them in their homes. The Amish do not oppose the telephone itself, but they worry about its convenience. They reason that if people had phones in their homes, they could too easily make a call and might not bother to hitch a horse to a buggy and drive down the road to actually visit a friend or relative.

Amish homes do not appear to be very different from other rural homes in the region. Most are painted white with no shutters or fancy trim. The bright green or blue curtains are their most striking feature.

Amish homes have modern bathrooms and kitchens outfitted with gas stoves and propane refrigerators. Kitchens are typically lined with cabinets made by local Amish craftsmen. Until recently, the Amish used wood stoves as well as dry sinks and hand pumps. Today, in addition to refrigerators and stoves, many Amish homes have washing machines and dryers powered by natural gas. They use gas, but not electricity. As the Amish wryly point out, no one has yet figured out a way to operate a television on natural gas. In fact, because they often cook for large groups of people, many Amish households have *two* stoves and refrigerators.

Downstairs rooms are large, with wide doorways to accommodate the gatherings during religious services. The living room usually has a sofa, stuffed chairs, and a rocker, and bedrooms are plainly furnished, except for a handsome quilt on the bed. All of the furniture is plain, with no print patterns. Only calendars and framed religious sayings are permitted on the walls. Years ago, church rules forbade mirrors, as well as most pictures and other fancy decorations.

Propane lanterns are now used to light Amish homes, having replaced more traditional oil lamps. Lanterns may take a few moments to light, but they illuminate as well as a 100-watt bulb.

Traditionally the Amish relied upon wood heat, but many homes are now equipped with gas or oil heaters located in the living room. The Amish do not have central heating, viewing it as an unnecessary comfort, and during the winter, the upstairs bedrooms become quite chilly.

Many Amish women are accomplished craftspeople and spend their "spare time" making quilts, often spreading out a quilt in progress on the living room floor. Quilt designers, though limited by restrictions on depicting flowers, animals, people, and other representational designs, compose original, striking geometric patterns with bright, strong colors. Highly prized by the Amish and "English" alike, these quilts are kept for use by a family or are sold for income. ✖

A typical Amish table setting includes bread, which precedes an abundance of food.
This setting of plain dishes and silverware is for an older couple living
in their retirement in the Grossdadi house.

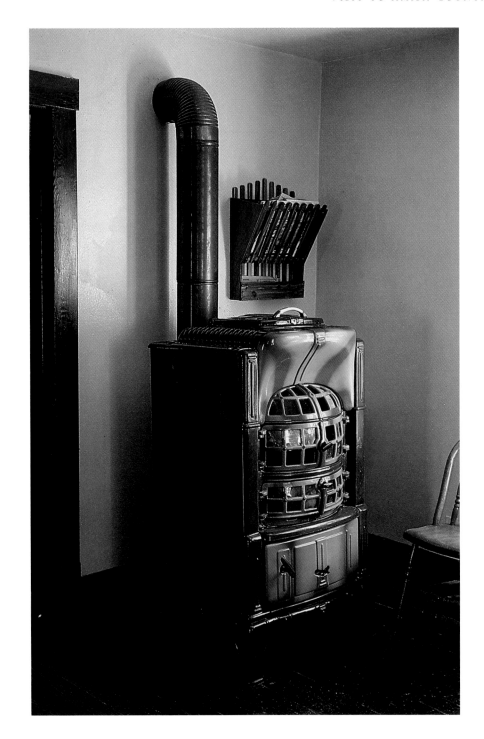

The Amish once made their own soap. Today, they are more likely to purchase bars of Ivory at a local grocery or dry goods store. Amish women still practice frugal ways, spending as little as $25 every two weeks for groceries.

Central heating is considered an unnecessary comfort among the Amish, who instead rely upon wood stoves or space heaters, such as the one depicted here. During bitter weather, families gather together around the small circle of warmth generated by the heater.

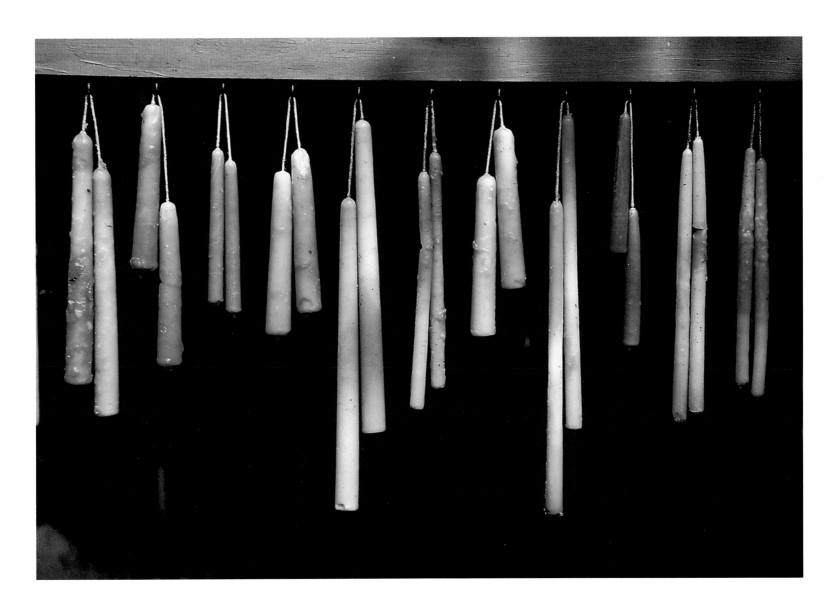

Just as early settlers provided for themselves, the Amish once made candles to light their homes,
either by pouring hot tallow in molds or dipping strings in the tallow. These dipped candles are hanging up
to cool and harden before they can be used.

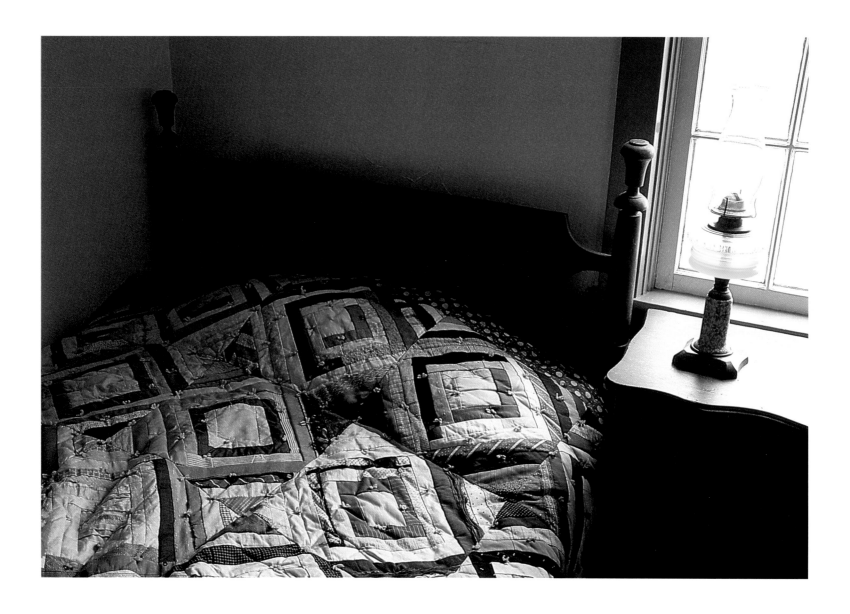

An oil lamp provides sufficient light for a little late night reading. However, the Amish retire
early because they will rise again before dawn to begin the work of another day.

An ironing board is a familiar sight in an Amish home. Women still use irons heated on the stove to press shirts, dresses, and other clothing. Fortunately, clothes are now made with polyester blends that reduce the amount of ironing time.

Some Amish women still use washboards to vigorously scrub away at grass stains and dirt. However, most now depend upon wringer washers powered by gasoline engines similar to the ones on lawn mowers.

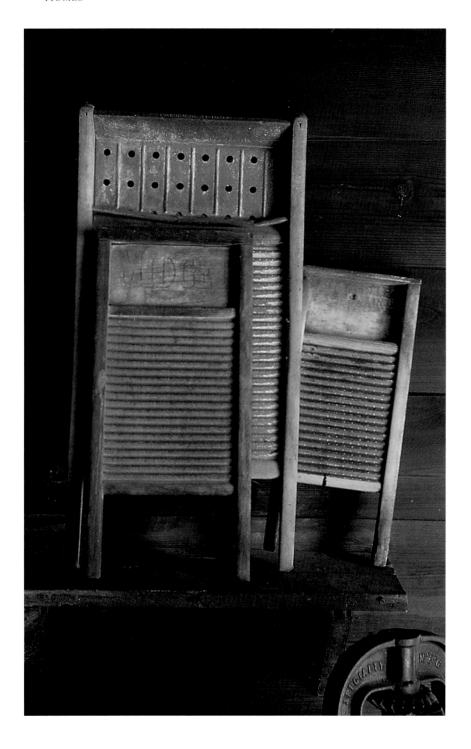

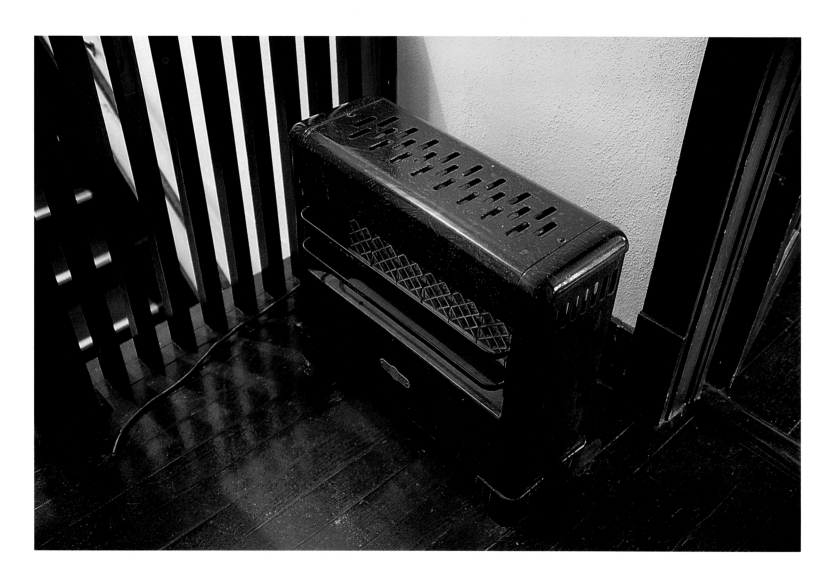

Amish homes do not have central heating—only a stove placed in a living room or perhaps a second heater in an upstairs hallway. Bedrooms remain unheated and during those cold winter nights everyone must burrow under layers of blankets and quilts.

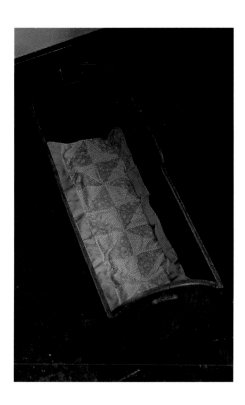

Made by an Amish craftsman, this cradle is designed with handles so it can easily be moved about the house, providing a convenient means of rocking the baby as the mother goes about her chores. It is fitted with an Amish crib quilt to keep the baby warm and comfortable.

Today, the Amish rely most often on propane lanterns. However, with glass chimneys, oil lamps like this one very much represent the traditional way of life of the Amish.

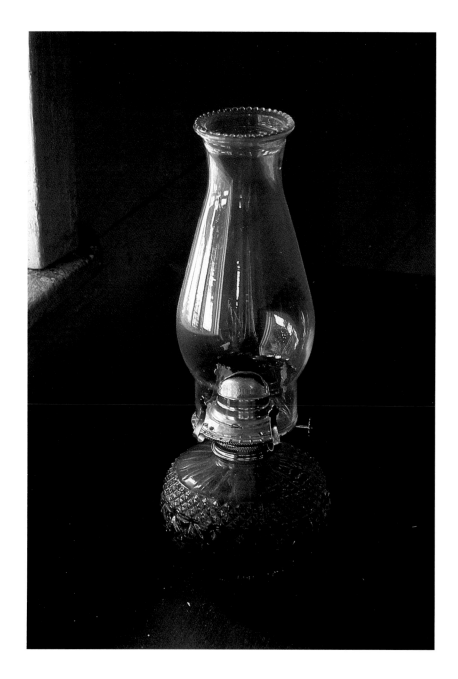

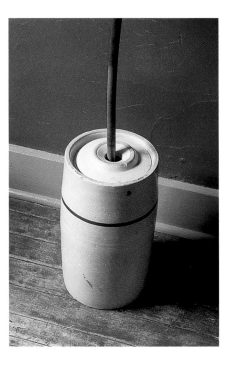

The Amish believe in providing for themselves. If they have a cow, or perhaps a dairy herd, they not only have their own milk, but they also can churn butter for the table or to sell to tourists.

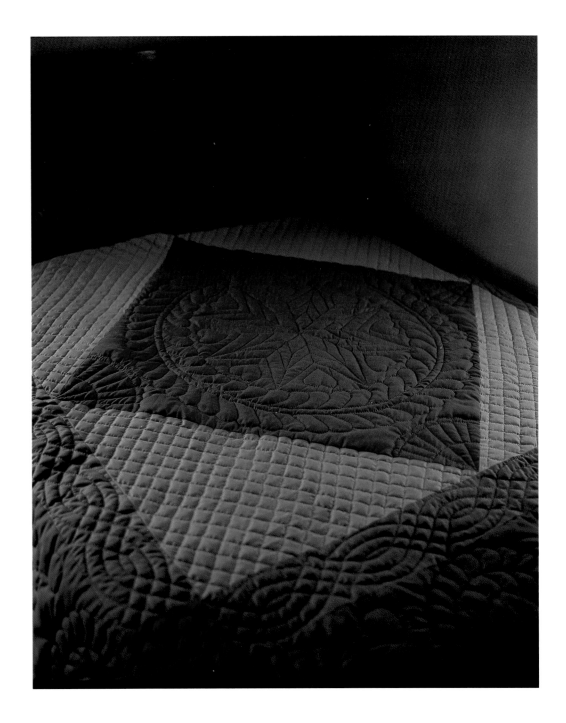

Quilts typically adorn beds in Amish homes. Women gather and make the quilts in striking geometric patterns. These remarkable creations are passed down through the generations.

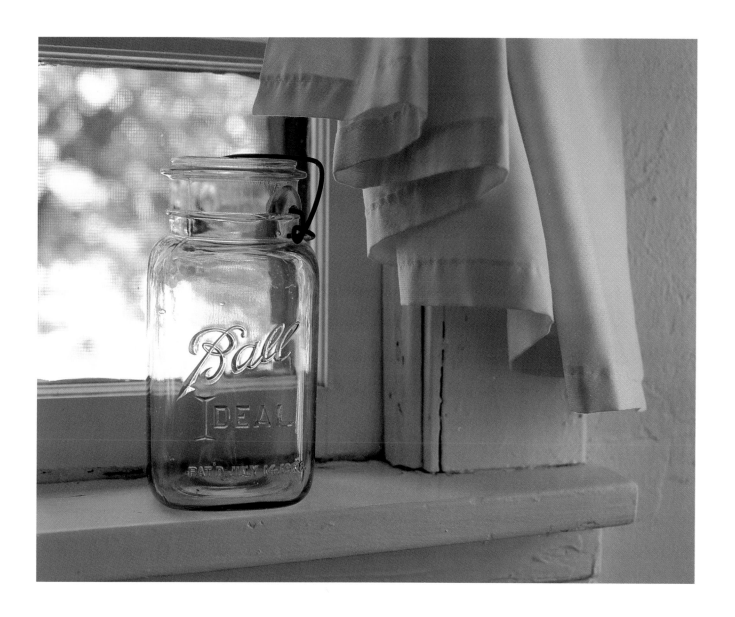

Ball Mason jars, such as the one in this window, clearly signify the Amish way of life, especially the frugality and productiveness of these people. Every year, girls and women put up enormous amounts of fruits and vegetables from orchards and gardens.

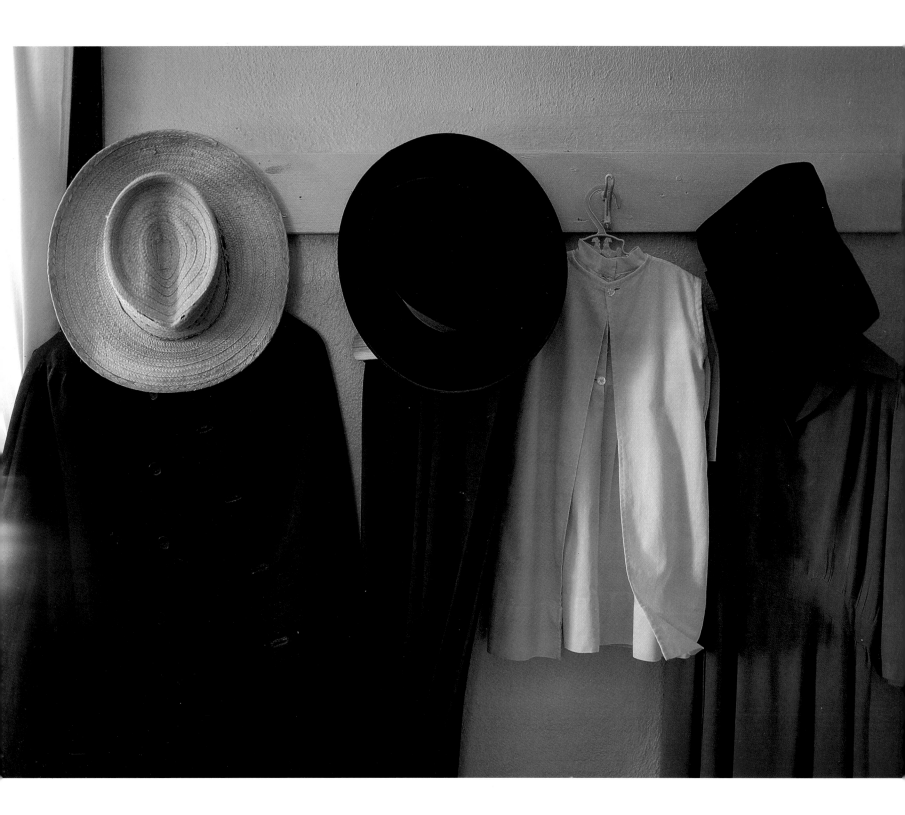

Dress

OFTEN SAYING THAT "the old is the best," the Amish have kept the same style of dress while the rest of the world has embraced the latest fashions. Amish clothing styles date back to the rural dress of seventeenth- and eighteenth-century Europe.

Along with the horse and buggy, their choice of dress reflects how the Amish *live* their faith. Dress identifies the Amish as members of a special group. Through standardized dress and hair styles the Amish believe they express loyalty to their community, as well as humility. By surrendering control over their appearance they demonstrate that they, as individuals, are less important than the group.

Amish women make all of the clothing for their families, using treadle sewing machines and brown paper patterns handed down through the generations. Today, polyester fabrics have largely replaced cotton and wool. These permanent press materials have brought some convenience to Amish women, who still use heavy flatirons heated on the stove. Since the clothes are made from traditional patterns with solid-colored fabric, the Amish remain true to their history.

From about the age of eight, Amish girls, like their mothers, wear aprons and triangular-shaped capes over their dresses, indicating modesty—because the apron covers pregnant women and the cape allows mothers to nurse their babies discreetly. Amish girls and women also wear a white cap, or *Kapp*, made of Swiss organdy, often with a bonnet.

Amish boys wear adult-style suits consisting of a vest, suspenders, coat, hat, and broadfall trousers. Called "barn-door britches," the trousers are held up by suspenders so they hang loosely at the waist and have a wide flap that closes with hooks at the sides instead of a zipper in the front.

Worn by boys and men, the wide-brimmed hat is perhaps the most recognizable symbol of Amish dress. Starting at the age of two, boys wear straw hats in the summer and black felt hats or stocking caps in the winter. Outside the home, hats are worn nearly all the time.

During the winter months, black sack coats fastened with hooks and eyes rather than buttons are generally worn by boys and men for work. Frock coats with divided tails are reserved for church and other special occasions. These coats are made by tailors, often Amish widows who have taken up the trade. Men almost always wear a vest with their formal clothes.

The Amish are not allowed to wear clothing with patterns, which are considered fancy, even prideful. However, they love rich colors. On washdays, brightly colored dresses of purple, royal blue, green, and orange hang on the clotheslines. Turquoise and lime green shirts worn by men and boys also flap in the wind.

Amish women never cut their hair, which is braided and knotted at the back, while the hair of Amish boys and men is cut to the ear and worn without a part. Amish men are required to be clean-shaven until they are married. Afterward they must grow a full beard, without a mustache. They do not grow mustaches as a reminder that centuries ago European soldiers wore them. The choice symbolizes the pacifism that is fundamental to Amish beliefs. �֎

Dress, including the style of hats, is critically important to the Amish. Various examples of the standardized dress for men, women, boys, and girls hang on the wall of an Amish home.

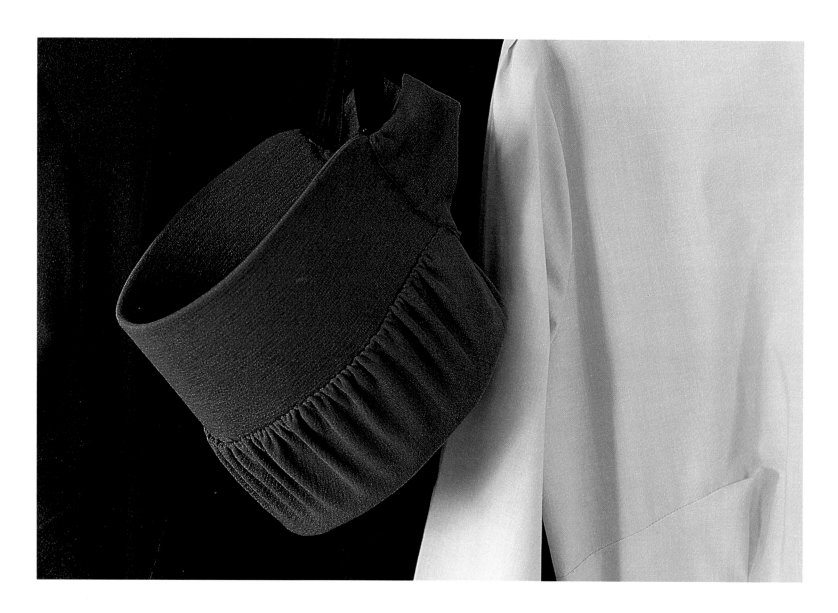

Amish bonnets sometimes vary in color and design, depending upon the region in which the Amish make their home. Girls and women always wear bonnets over white prayer caps. They take off their bonnets in the house and during warm weather, but must always wear their prayer caps.

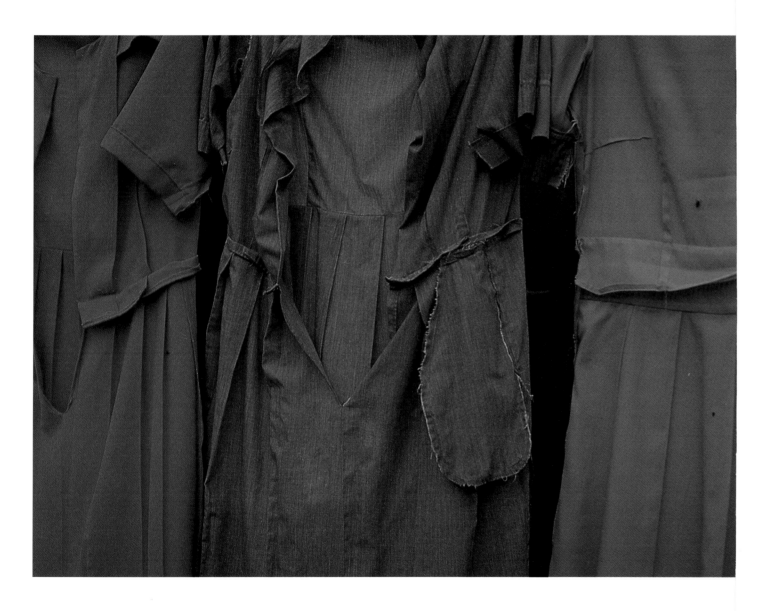

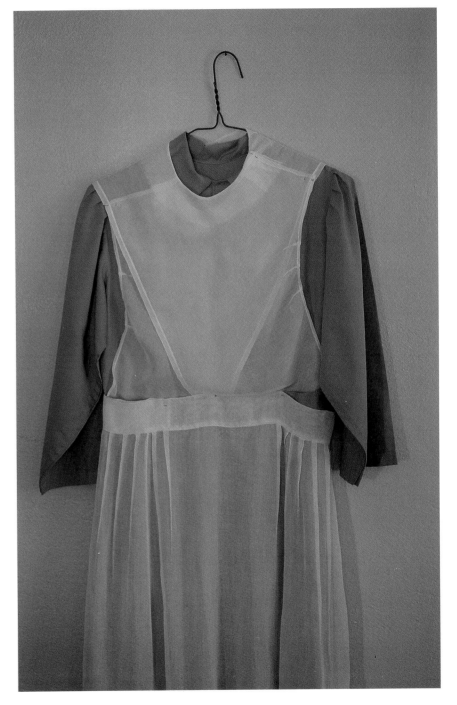

Girls and women must wear solids, never patterns. They compensate for this fashion restriction by emphasizing bright colors in their dresses—blue, purple, green. Even the shades of brown and grey are rich and striking.

When the Amish broke away from the Mennonites, who became known as the "button people," they persisted in wearing hooks and eyes instead of buttons on their black coats. The Amish follow this tradition to this day.

Serving as an important symbol, style of dress clearly distinguishes the Amish as a group and helps them to separate themselves from the world. Through dress, the Amish give witness to their faith as well.

VISIT TO AMISH COUNTRY

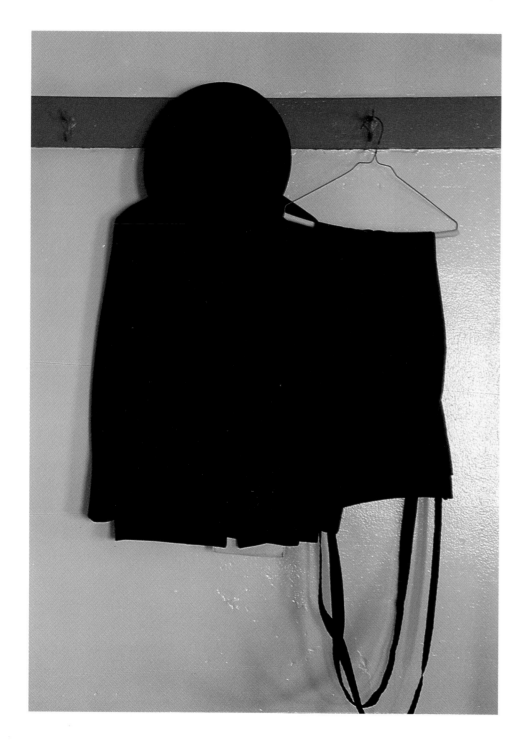

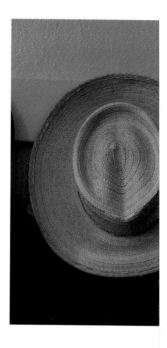

During the warm months Amish men and b[...]
as they work about their farm. During the w[...]
stocking caps or black felt hats, which are also [...]
occasions.

For the sake of modesty, Amish boys and me[...]
instead of belts so that their trousers may fit [...]
trousers, and coats have come to be a familia[...]
and simple" life of the Amish.

Amish boys and men wear plain shirts of bright colors—blue, lime green, turquoise—that contrast strongly with their black pants, suspenders, and hats. They also get as much wear as possible out of their work clothes, as evidenced by the patch on this shirt.

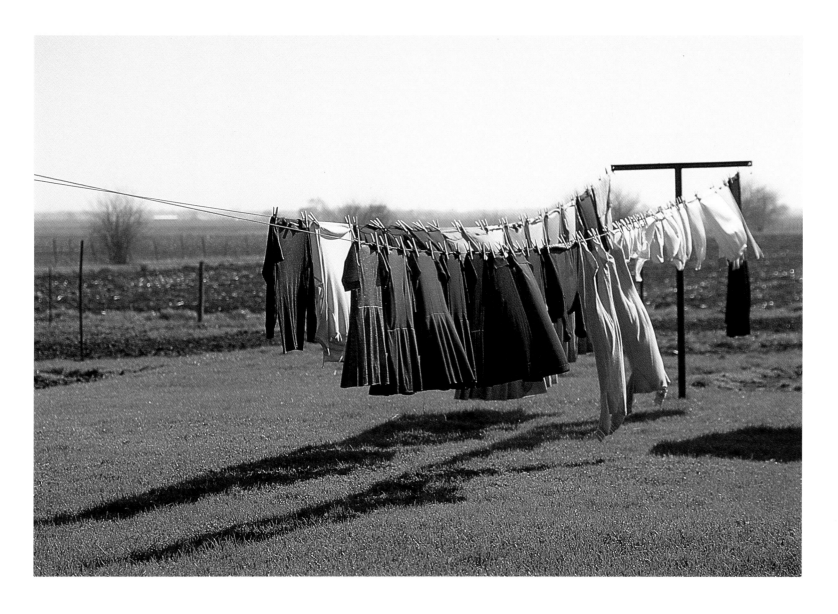

*No utility lines are strung to Amish homes. Instead you may see T-shaped poles for hanging laundry in
the yard. Here, shirts and dresses catch the April breeze against a backdrop of prairie that
sprawls uninterrupted for as far as the eye can see.*

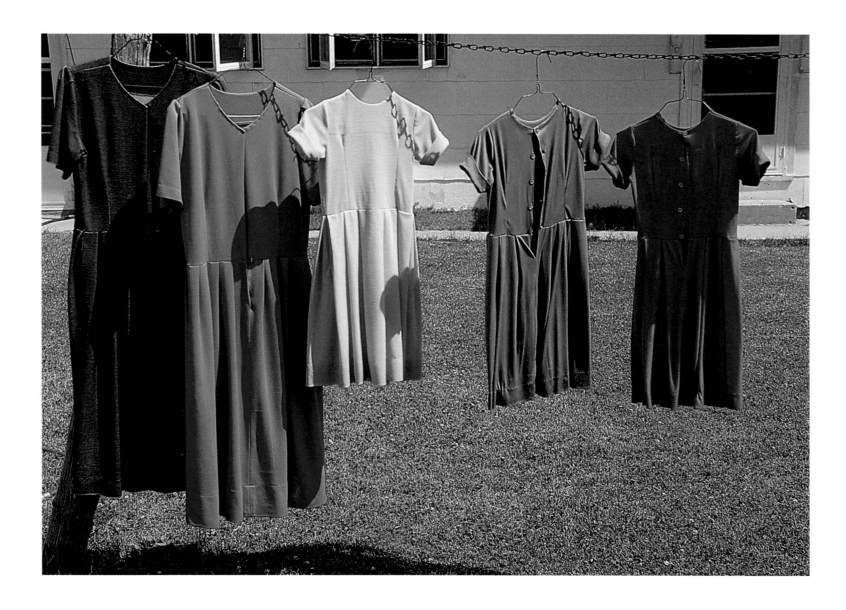

*Perhaps the most appealing feature of Amish yards is the clothesline from which hangs an
assortment of brightly colored garments. This group of dresses of various sizes and
colors is particularly charming.*

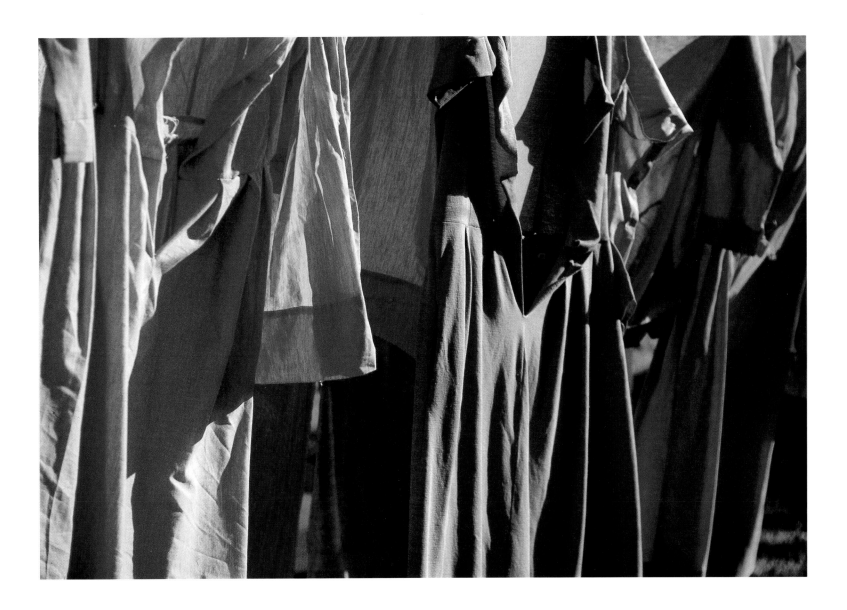

Purple dresses are radiant in the sun as they dry on the clothesline in an Amish yard.
Although tastes vary from one region to another, many Amish women
favor clothing in rich hues.

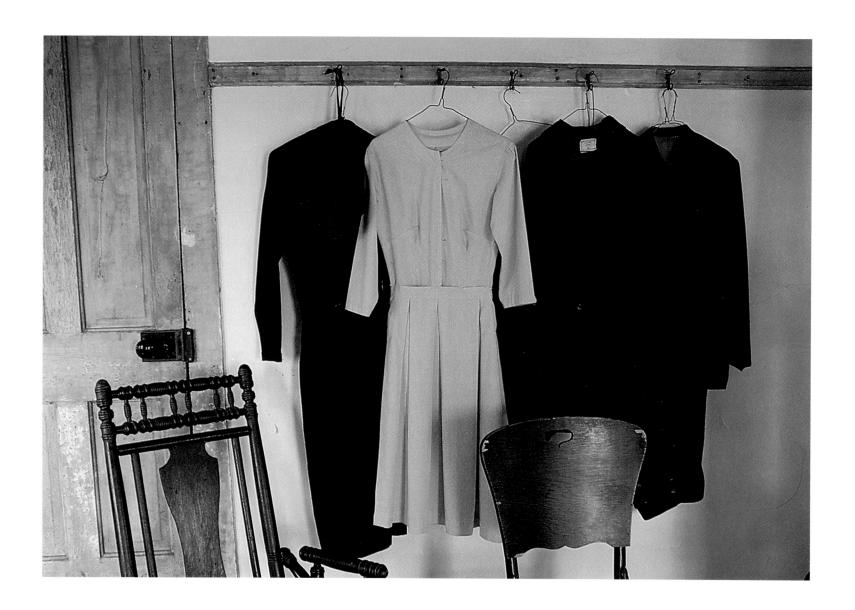

The style of Amish dresses has not changed appreciably in the past hundred years. While the clothes may now be made with polyester blends, the basic pattern has been handed down over the generations. Dresses are still fastened with straight pins.

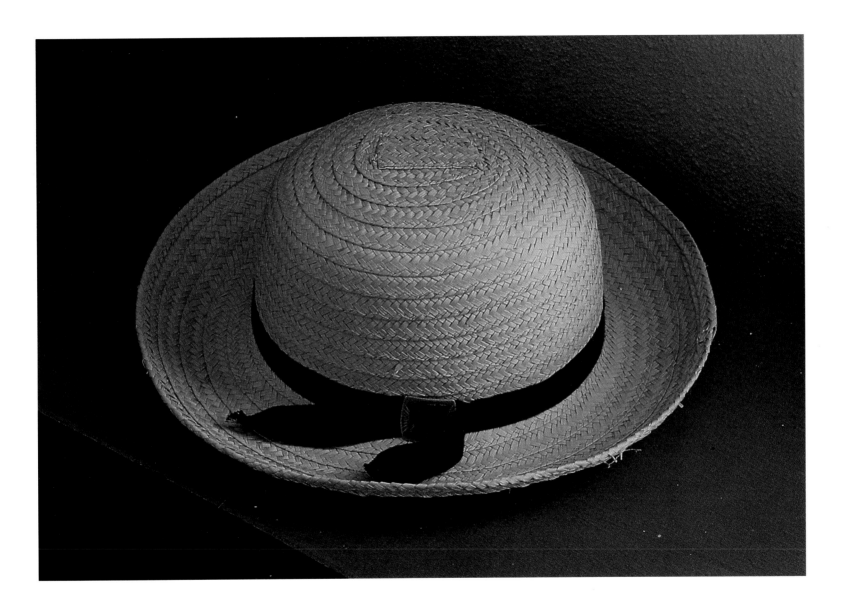

*Amish boys and men wear either black felt or straw hats for work, worship, and play. This boy's fancy hat
is reserved for formal occasions, such as weddings and religious services. Straw hats are used while
working in the fields during the warm months.*

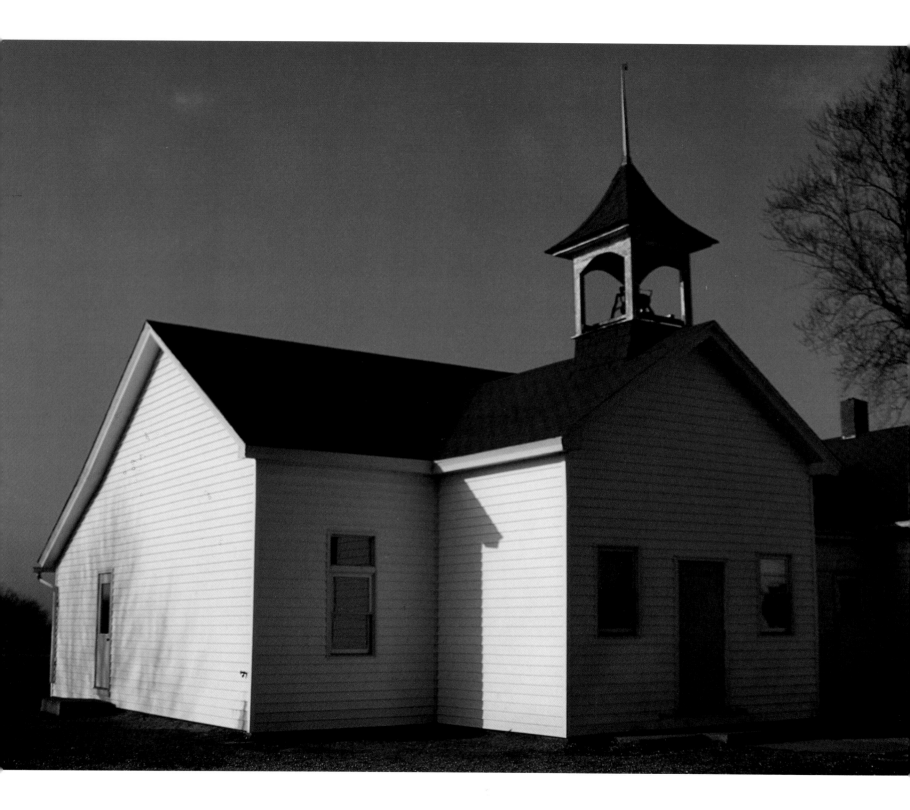

Learning & Trades

ALTHOUGH THEY HAVE attempted to remain separate from the world, the Amish have at times found themselves in serious conflict with the society around them. In the 1950s, they clashed with school officials because of their choice to not formally educate their children beyond eighth grade, believing that there is no need to be educated "over their heads."

In the early 1900s, Amish students attended one-room schools along with their "English" neighbors. As these schools began to consolidate into larger districts, the Amish viewed this trend as detrimental to their way of life. They thought it best that their children be educated close enough to home to walk to school. The parents also wanted to be able to take an active role in curriculum development and school activities. The Amish successfully established their own schools, often purchasing the one-room buildings left abandoned by consolidation, and have proved to be very competent educators. Teachers are usually single teenage Amish girls, who themselves are not educated beyond eighth grade.

For nearly two decades, the Amish struggled with school officials who insisted that Amish children attend school at least until age sixteen. There was a public outcry when dramatic news photographs showed terrified Amish children fleeing into the cornfields as school officials in Iowa attempted to force them onto schoolbuses. The Amish rarely take legal action—viewing it as a form of conflict—yet they allowed a suit to be brought on their behalf. Finally, in 1972, the Supreme Court ruled that attempts to coerce Amish children into attending public schools violated their freedom of religious choice. The court also commented that despite their lack of higher education, the Amish were not a burden on society.

Because of their practical skills, the Amish are quite self-sufficient. Although they are not trained in professions, such as doctors and lawyers are, they read a great deal and are often better informed about world events than more formally educated people.

The Amish have always preferred to be farmers, but in recent years, with growing families and the high cost of land, they have begun to seek work in other trades. Many church leaders have been uncomfortable with the transition, but the Amish must support their families. The changes have been permitted as long as the work continues to be "by the sweat of their brow." The Amish have proved to be highly skilled craftspeople. Scattered among the Amish farms are many small businesses, usually run out of homes, offering furniture, quilts, and other Amish-made goods to tourists. Hand-painted signs advertise baked goods, cheese, homemade candies, and fresh eggs. Harness makers, farriers, and blacksmiths, along with dry goods merchants, buggy makers, and other business owners who cater to the Amish are also springing up in the countryside.

There is a continuous awareness of the quiet of Amish country—a quiet so deep and so fulfilling that it seems to have a presence of its very own. There is little traffic, only the clip-clop of hooves, the gentle slap and jingle of harnesses, and the trill of red-winged blackbirds perched on every other fencepost. �

Amish children once shared one-room schools with "English" children. However, as these country schools consolidated into large districts, the Amish formed their own schools, often purchasing the old buildings or constructing new ones.

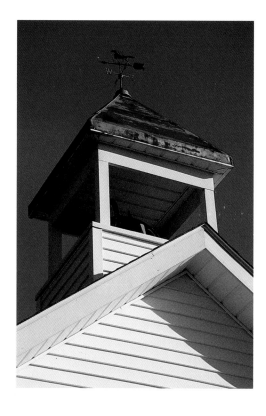

Perched atop a one-room school house, this bell rings across the rural landscape calling Amish children to school every day through the autumn, winter, and spring. A cupola, complete with weather vane, protects the bell from the rain and snow.

Amish children usually live close enough to walk to school along the country roads, much as all farm children did in the nineteenth century. Amish parents take a very active interest in the school.

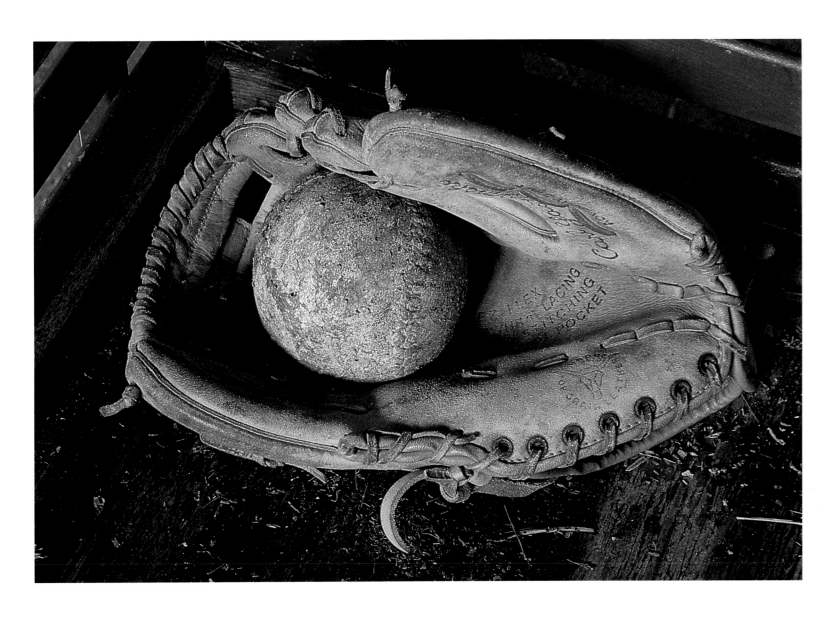

With their emphasis upon community, it is no wonder that group activities, including volleyball and
softball, are very popular among the Amish. Tossed into a child's wagon, this mitt and
softball certainly evidence plenty of wear.

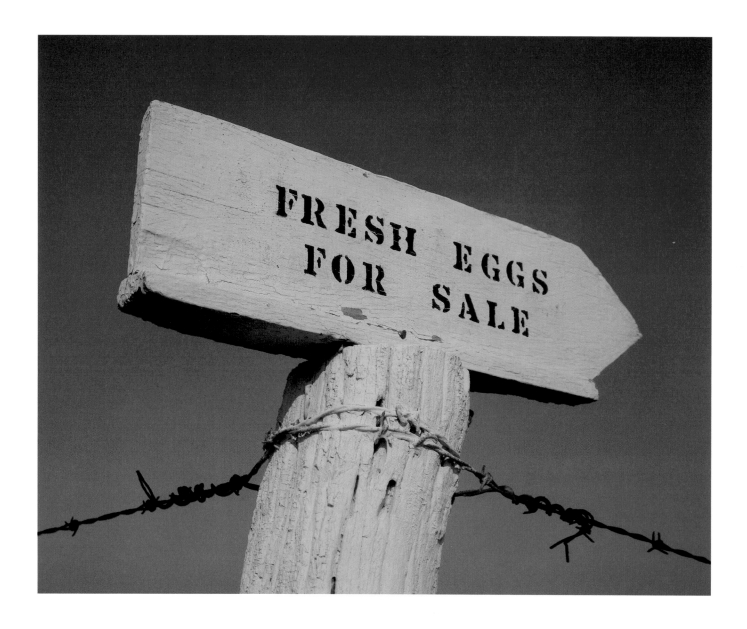

Eggs are frequently sold directly from Amish homes to visitors, as indicated by this hand-stenciled sign pointing the way up the long lane to the farmhouse. The sales will help supplement the family's income.

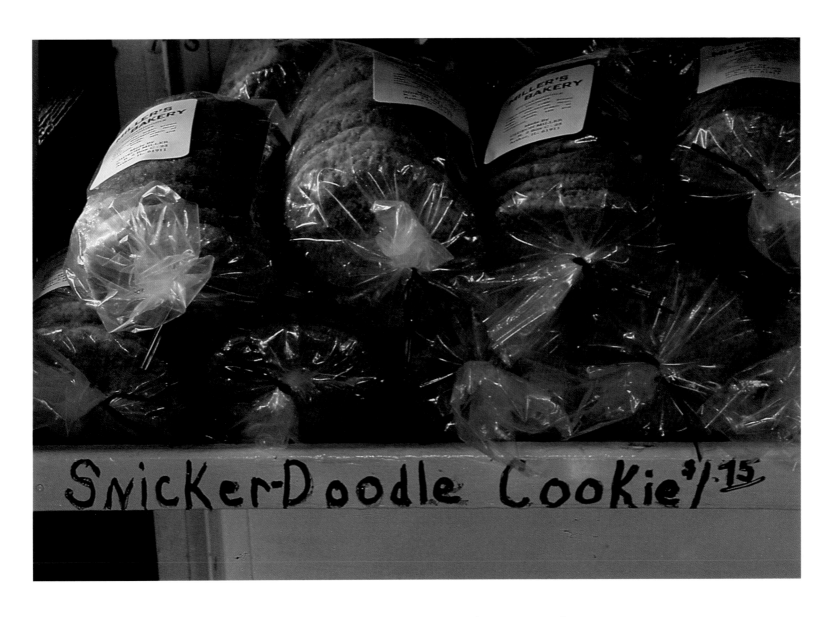

Snicker doodles are not only a popular treat in Amish homes, but enterprising women also
make large batches of the traditional cookies to sell to tourists at bakeries
set up on Amish farms.

In the autumn large quantities of apple butter are made from fruit grown on Amish farms.
The apple butter, cider, and other products of the autumn harvest are sold at roadside stands.

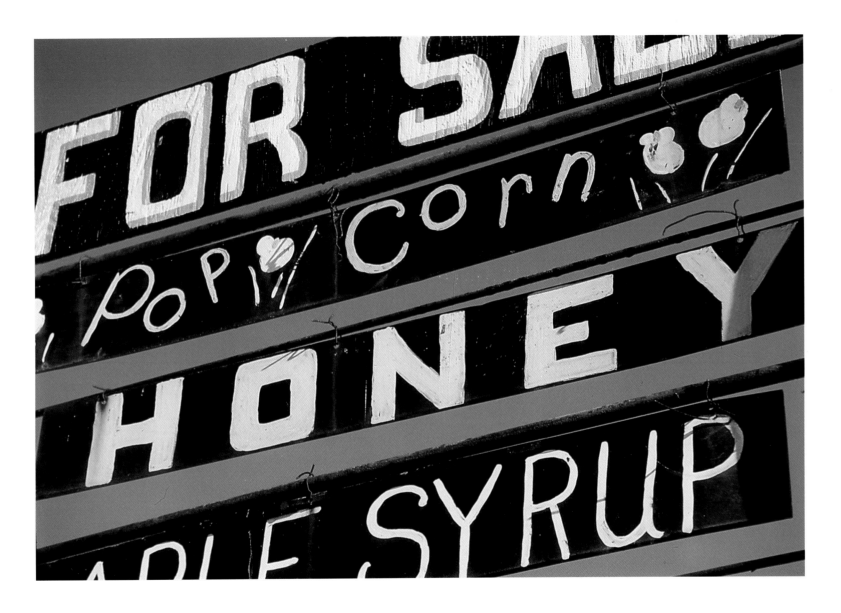

This colorful sign advertises some of the goods offered for sale at the roadside stand on an Amish farm. All of these products came from this family's farm.

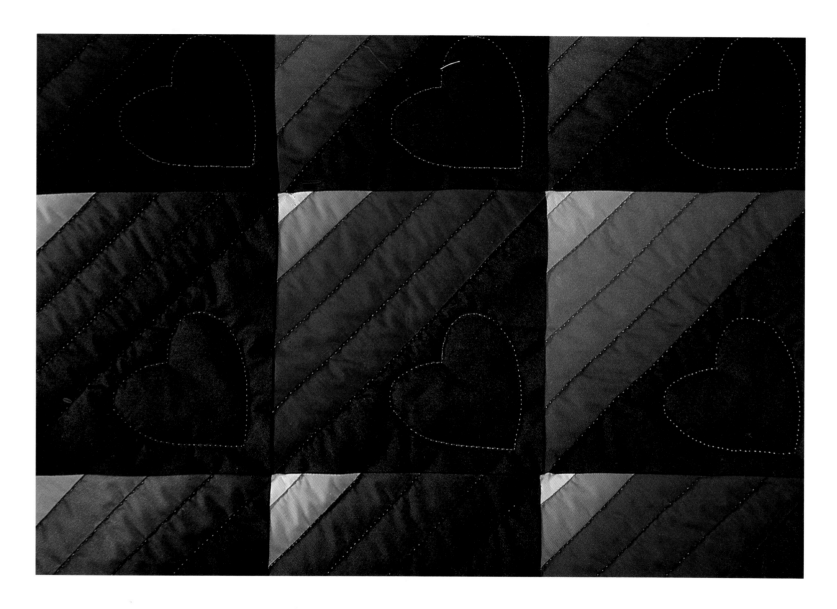

*This classic pattern is known as "Amish Shadow." The design is a remarkable contrast
of black triangles and bright stripes that mirror each other in
a very enigmatic yet lovely manner.*

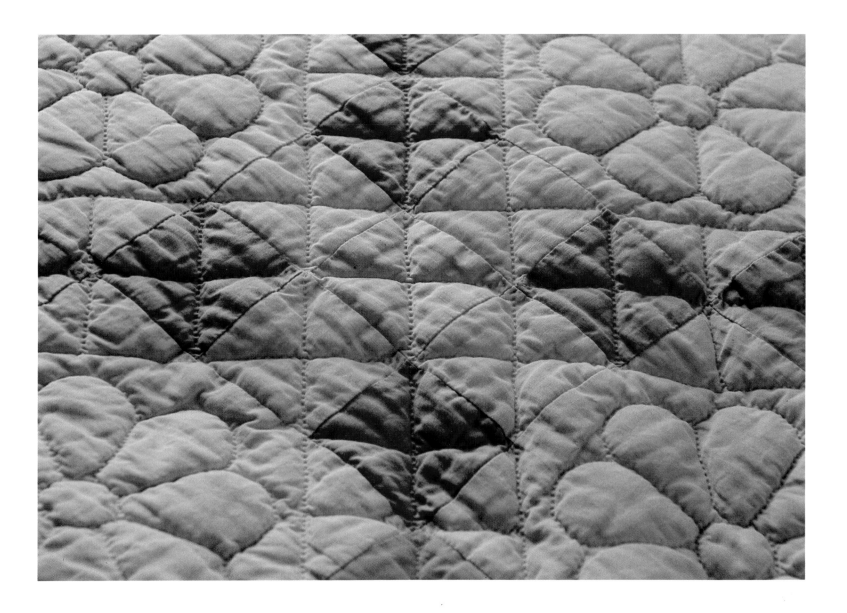

Quilts are as much a symbol of the Amish way of life as buggies and black hats. All of the meticulously
stitched quilts are made in colorful, geometric patterns for personal use or
"for the public," meaning they will be sold in shops.

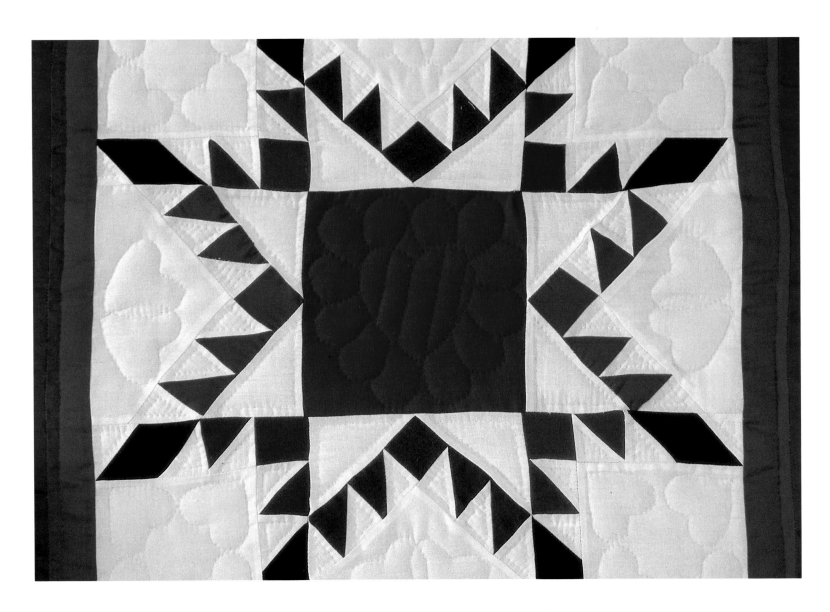

Amish quilts may be designed only in geometric patterns—never with representational figures.
Using squares and triangles, Amish women nonetheless create strikingly unique designs
for which they are known worldwide.

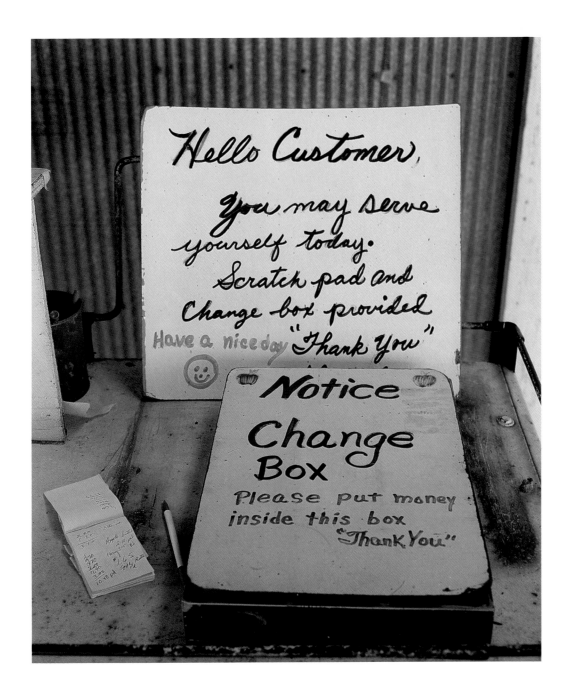

The Amish are highly respected for their ability with wood. They often form carpenter crews and construct homes that are prized because they are "Amish-built." In their woodworking shops, they make cabinets of excellent quality.

Traditional country people who are very busy on their farms, the Amish rely upon the "honor system" in many of the transactions at their roadside stands. This operation includes a change box and advises customers to serve themselves.

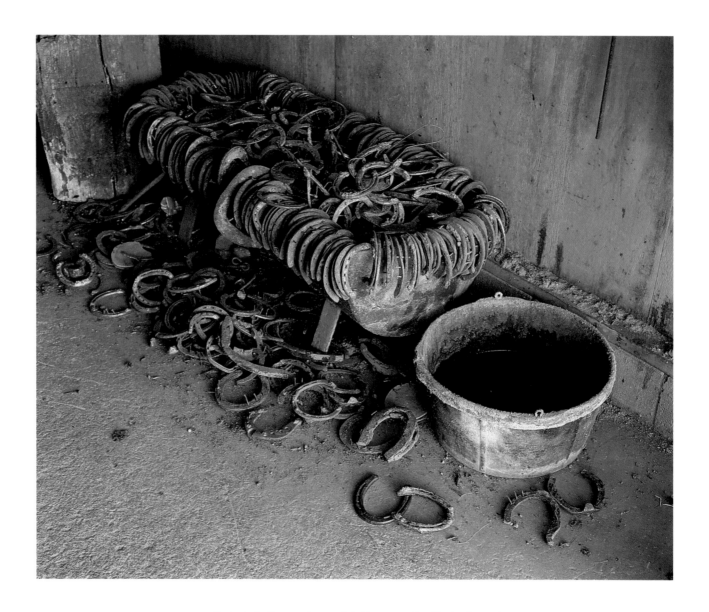

*Farriers in Amish country do a great deal of business as indicated by the collection of
horseshoes that fringe this water trough. The farrier must fit new shoes on
both the workhorses and driving horses.*

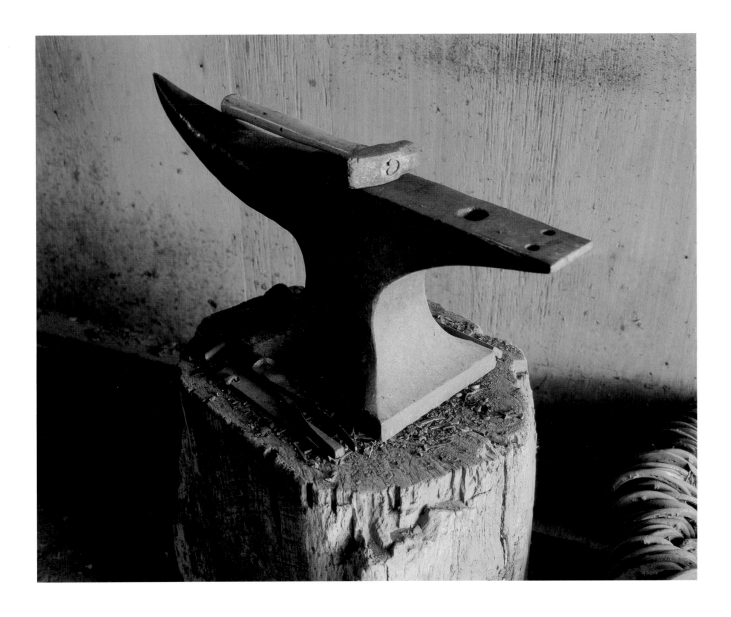

*A number of businesses, such as harness shops and farriers, cater to only Amish families
in the settlement. The details of a farrier's shop include the anvil and hammer
used for shaping horseshoes.*

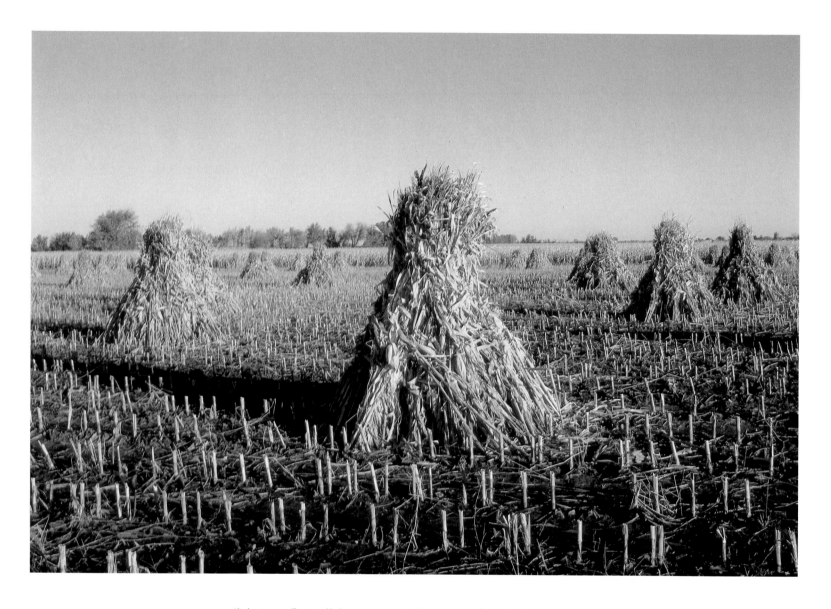

*Shocks of corn still grace fields during autumn in Amish country. Once the corn has been picked and hauled
to the crib, the stalks are gathered together to form a picture of traditional life that disappeared from
most of rural America many years ago.*

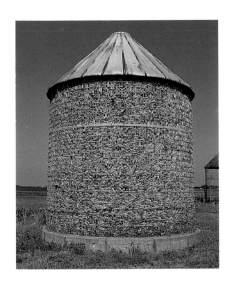

Most Amish farmers now harvest corn with mechanical pickers drawn along by teams of workhorses. The corn may then be stored in conical metal cribs that bulge with the ears of bright yellow grain.

This detailed photograph illustrates just how tightly packed the ears of corn are. Shoveled out as needed, the corn helps sustain livestock on the farm over the course of the year, or it may be sold to a neighbor.

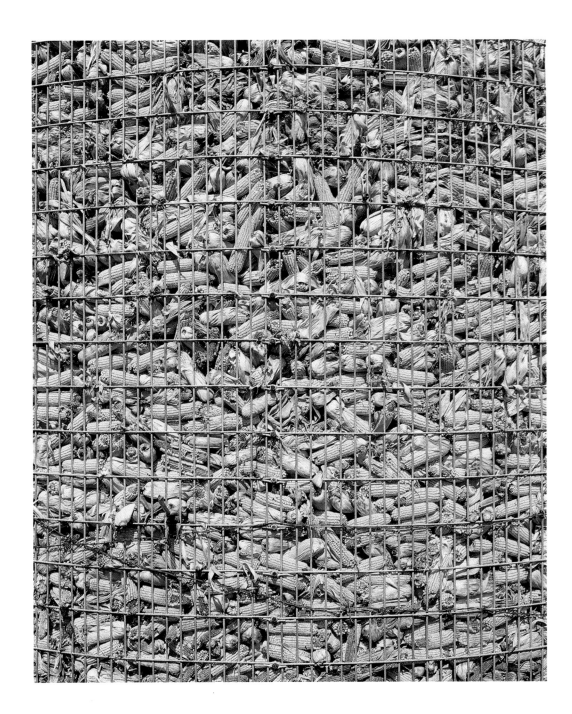

The Amish use some modern farm tools and equipment, such as this hay rake that is drawn by horses instead of a tractor. As the hay is being raked into windrows that loop the fields, one hears only the click-click of the machine and the gentle slap of the harness.

Nothing compares with the fragrance of hay freshly cut and raked into windrows. Once the hay has dried in the sun a baler will make its way over the field. The baler is like those used by other farmers—except it is drawn by a team of horses.

Keeping Separate

OVER TIME, MANY people have made fun of the Amish, simply because they follow a distinctive way of life. In more recent years, however, people have come to respect Amish culture. Their settlements have become prime tourist attractions. The Amish have been dismayed by the intrusions and the commercial exploitation, yet they realize their own livelihood depends in part on the tourists who purchase their handmade goods and fresh produce.

With only occasional problems of crime and divorce, Amish life can appear idyllic. Even so, as one Amish man said, "It's not all pie and cakes." About twenty percent of young people choose not to become members of the church when they reach adulthood. When an Amish man joins a Mennonite or other similar, but less demanding, church, the Amish say, "He got his hair cut." If the young person leaves the Amish faith altogether, they say he or she "went English."

As much as they wish to separate themselves from the world, the Amish do take advantage of hospitals, as well as public roads. They have clearly accepted many technological innovations while rejecting others. The Amish believe that they have maintained control over their lives, while other people have allowed their lives to be shaped by technology.

The Amish are now exempt from paying social security tax. For years they paid into the fund, but refused to accept benefits because they believe in taking care of themselves. They never send old people to nursing homes. When too old to work, grandparents move into adjoining houses called *Grossdadi* houses to be cared for by their children.

The Amish do not purchase health or life insurance. When someone is hospitalized for an illness or injury, members of the community raise the necessary funds to help pay the bills.

Despite their outward appearance, the Amish have indeed changed over the years. They are not as "plain" as they may appear to be, and they are not without their difficulties. In their world the individual occupies a small place, but is always valued. In the larger culture, the individual is foremost, yet people often feel lonely and forgotten.

In many ways the Amish have remained "in this world, but not of it." Our clearest insights can come from studying both our culture and theirs. Perhaps then we may better understand why the Amish have quietly gone their own, separate way. �֍

Amish girls and women always wear a prayer cap of white organdy. Depending
on the weather, they may also wear a bonnet over the prayer cap.
Here, the prayer cap is visible inside the bonnet.

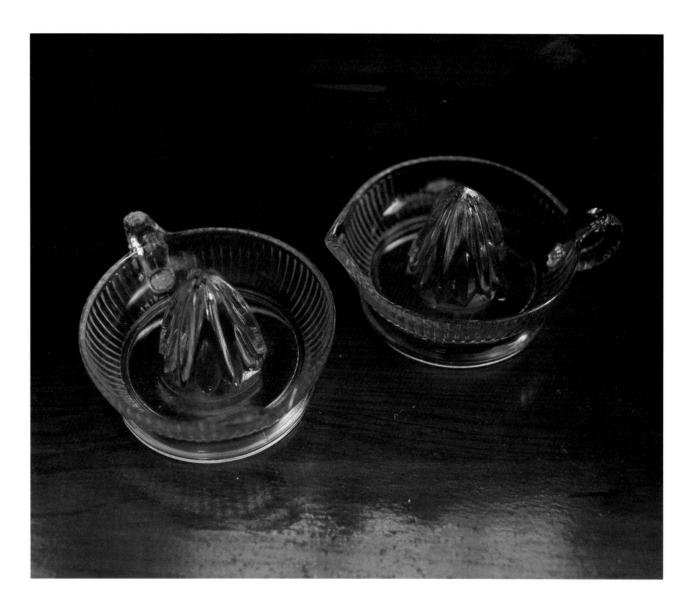

Although not uniquely Amish, these lemon squeezers glimmering in a dry sink do suggest their penchant for work and the absence of electrical appliances in their homes. Amish women spend considerable time in the kitchen, where most work is done by hand.

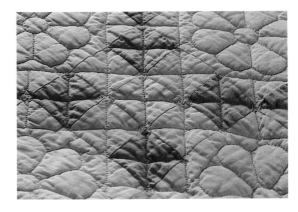

Lovely patchwork quilts are made "for the public" to supplement family income, thereby enabling the Amish to continue to live independently. Quilts are so much a part of their lives that people have come to identify the Amish with their quilts.

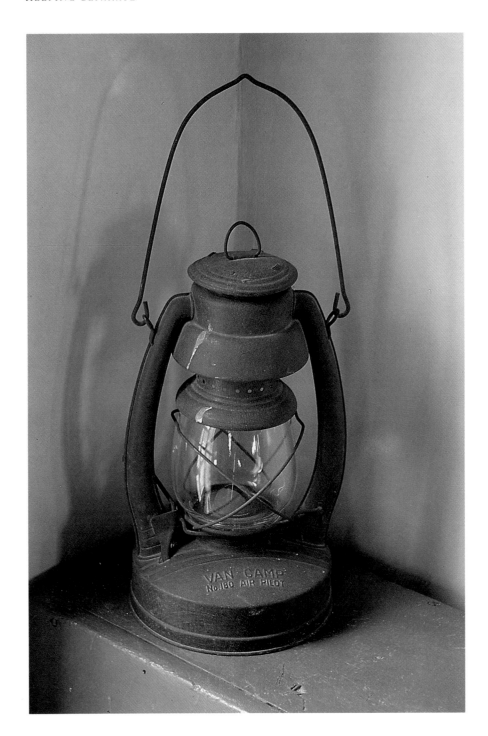

Tucked in the corner by the door, this lantern is ready should an Amish man be called out to the barn to help with a calving. Oil lamps and lanterns are a familiar sight in Amish homes.

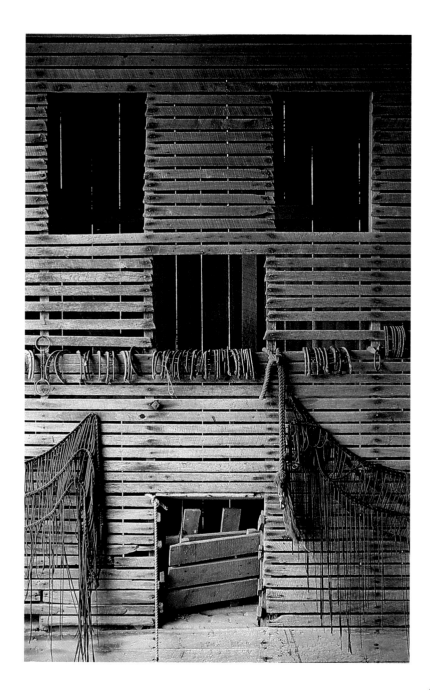

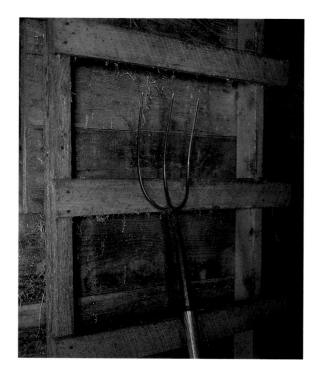

Leaning against the wall in an Amish barn, the tines of this pitchfork gleam in the dim light. The Amish believe that it is best to work by the sweat of one's brow, so much of the labor on their farms, such as pitching hay, is done by hand.

Horseshoes and harnesses line the walls of this corn crib attached to an old Amish barn. The gaps between the slats of the crib allow air to circulate around the ears of corn, which dry naturally over the course of the autumn and winter.

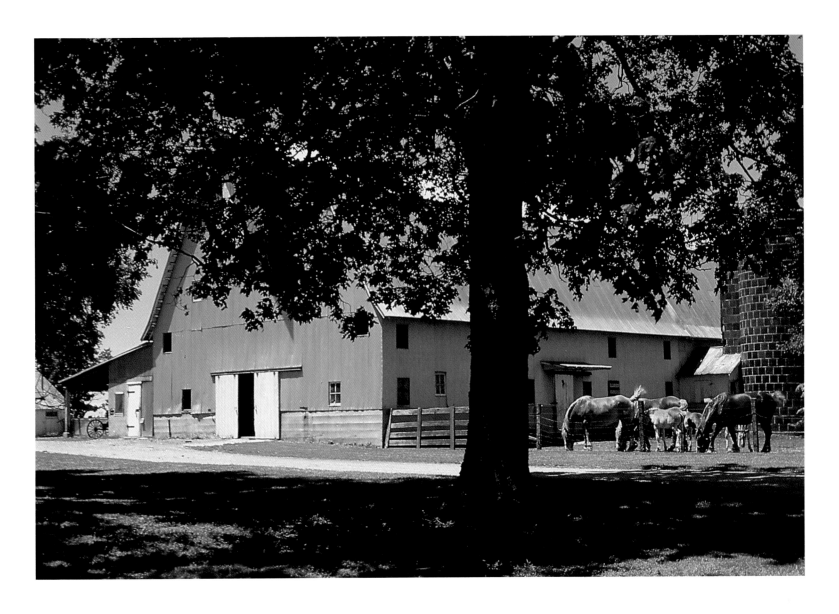

A sense of quiet tranquility pervades Amish country, as indicated by this farmyard.
Large trees shade the yard with the barn in back and horses peacefully grazing
in the adjoining pasture.

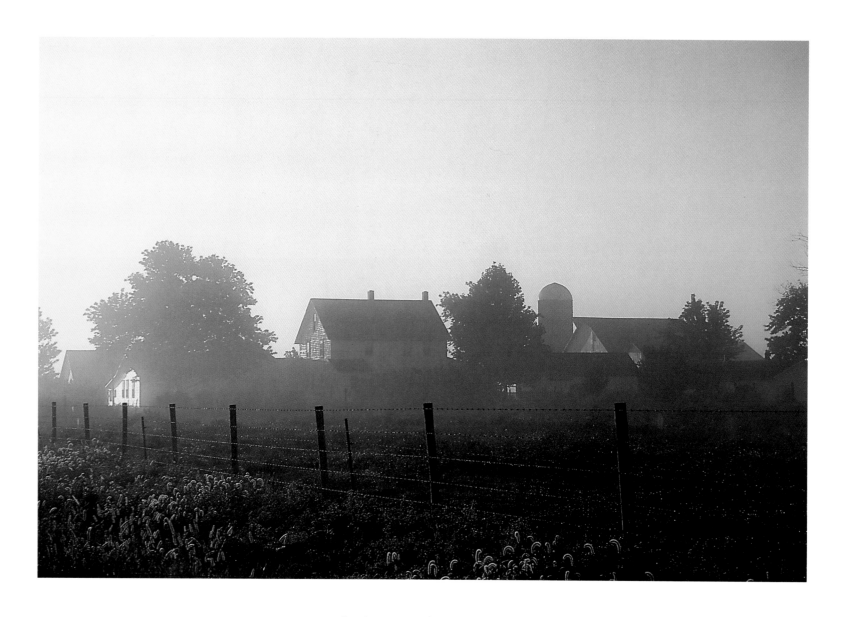

Early in the morning, fog settles over the low ground and dew glistens
on the strands of fence wire. In the background, an Amish farm
catches the first rays of sunrise.

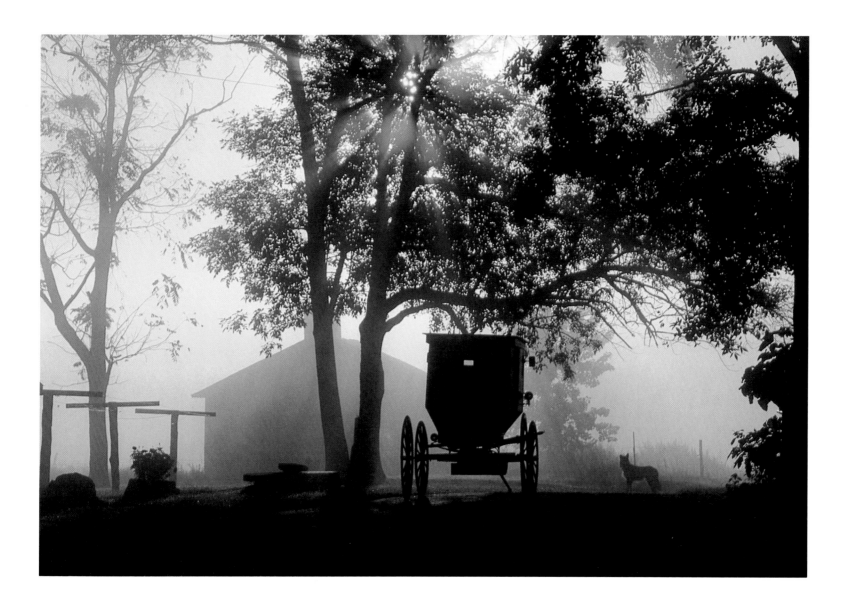

*The fog has not yet burned off in this farmyard, even though the sun is splintered through
the trees. Parked in the lane, with a curious farm dog nearby, the black buggy
indicates that this is indeed an Amish farm.*

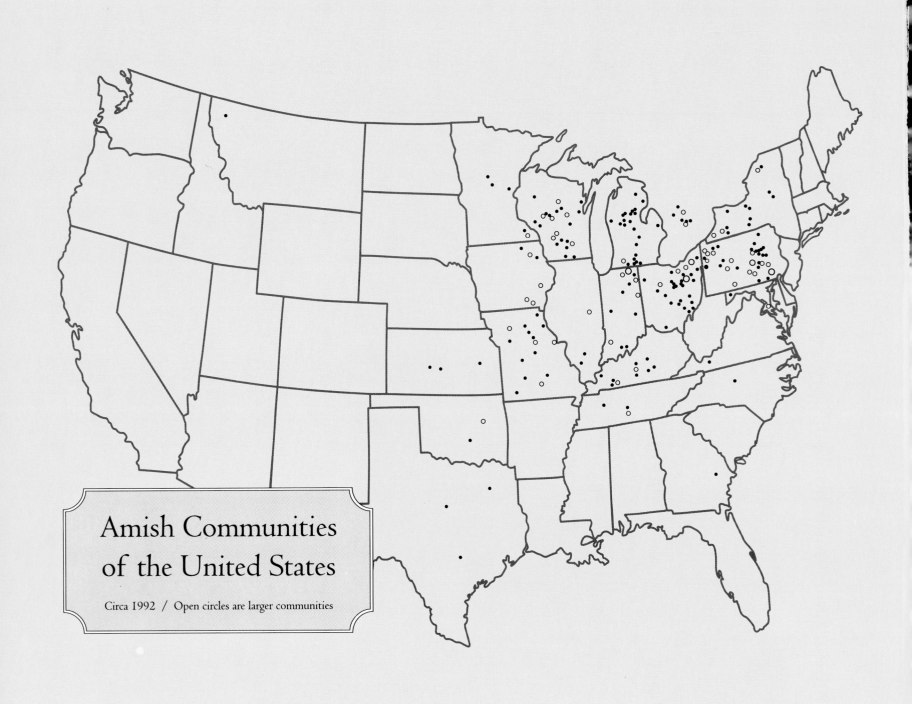

Amish Communities
of the United States

Circa 1992 / Open circles are larger communities

Reading

THE FOLLOWING MATERIALS were consulted in preparation of the text for *Visit to Amish Country*. Readers wishing to learn more about the Amish will find these books to be both enjoyable and informative.

Hostetler, John A. *Amish Life*. Scottsdale, Pa.: Herald Press, 1952.

———. *Amish Roots*. Baltimore: Johns Hopkins University Press, 1989.

———. *Amish Society*. Baltimore: Johns Hopkins University Press, 1980.

Kline, David. *Great Possessions: An Amish Farmer's Journal*. San Francisco: North Point Press, 1990.

Kraybill, Donald B. *The Puzzle of Amish Life*. Intercourse, Pa.: Good Books, 1990.

———. *The Riddle of Amish Culture*. Baltimore: Johns Hopkins University Press, 1989.

Mabry, Rebecca. *Be Ye Separate: A Look at the Illinois Amish*. Champaign, Ill.: Champaign News-Gazette, Inc., 1989.

McLary, Kathleen. *Amish Styles: Clothing, Home Furnishings, Toys, Dolls, and Quilts*. Bloomington, Ind.: Indiana University Press, 1993.

Nolt, Steven M. *A History of the Amish*. Intercourse, Pa.: Good Books, 1992.

Scott, Stephen. *Amish Houses & Barns*. Intercourse, Pa.: Good Books, 1992.

Scott, Stephen, and Kenneth Pellman, *Living without Electricity*. Intercourse, Pa.: Good Books, 1990.

Book design, photo editing and managing editing by Evelyn C. Shapiro.
Design assistance and book production by Andrew Hunt.
Production editing by Rebecca Standard.

The type is composed in Monotype Corporation's Centaur,
based on Centaur Roman created by Bruce Rogers in 1915.

The illustrations were made from 175-line screen separations and printed in
four-color offset lithography on acid-free, recycled 100-pound Warren's Lustro Dull.
Soy inks were used, with a spot varnish applied to the printed photographs.
The jacket has been printed in four colors with a dull varnish.
The sheets were smythsewn in sixteen-page signatures,
and cased in ICG Kennett cloth.